IMAGES
of America

BETHEL TOWNSHIP, DELAWARE COUNTY

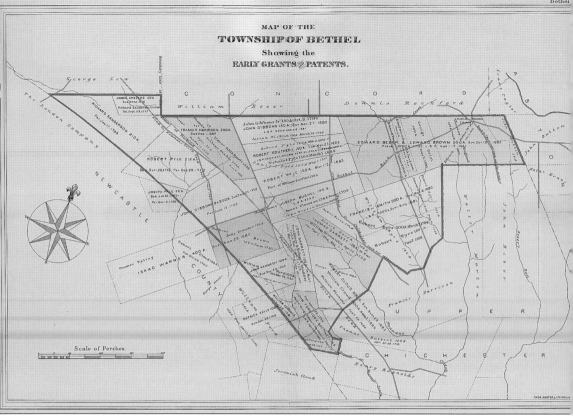

This map is an early depiction of the distribution of land in Bethel Township. The map shows the locations of local streams and early roads, while distinguishing the property lines of early farmers such as the Clouds and the Booths. (Courtesy of Reece and Mary Thomas.)

ON THE COVER: Parked outside of the Sarum Farm in Bethel Township is a bread truck from the Charles Freihofer Baking Company. The company was opened in 1884 in Philadelphia by Charles Freihofer, the son of German immigrants. By 1913, Charles, along with his brothers, had set up a commercial baking plant in Troy, New York. It is clear from this image that the Freihofer Company made local deliveries to Bethel Township residents. While the exact date is unknown, the truck appears to be from the 1910s or 1920s. Apparently, though the plant was based in New York, the Freihofer Company still had customers in the Philadelphia region after its move. (Courtesy of Romaine Trump Jones.)

IMAGES
of America

BETHEL TOWNSHIP,
DELAWARE COUNTY

Elizabeth McCarrick and
Faith McCarrick-Diskin with the
Bethel Township Preservation Society
Foreword by Dr. Mead Shaffer

To Autumn
Hopefully this book will bring
back all your good memories
of BTPS - we miss you!
Enjoy "Beth"
Elizabeth McCarrick
Faith McCarrick-Diskin

ARCADIA
PUBLISHING

Published by Arcadia Publishing
Charleston, South Carolina

Printed in the United States of America

Library of Congress Control Number: 2011938290

For all general information, please contact Arcadia Publishing:
Telephone 843-853-2070
Fax 843-853-0044
E-mail sales@arcadiapublishing.com
For customer service and orders:
Toll-Free 1-888-313-2665

Visit us on the Internet at www.arcadiapublishing.com

*In loving memory of Bethel's historic blacksmith
shop, a victim of progress.*

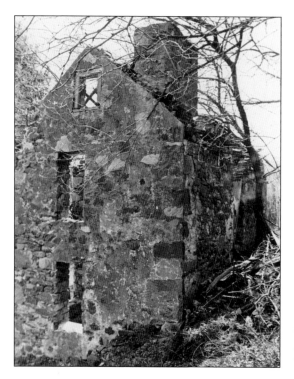

These ruins located on Laughead Lane truly show the age of old Bethel Township, founded in 1683. The building appears to be Swedish in origin because of the corner fireplaces. This was also a bank house. At one time, animals were kept on the ground floor. An old roadway appears to be in the front of the house as evidenced by a hedge of Osage orange trees that are no longer there today, but were commonly used to denote pathways and were used as natural boundaries planted by early settlers.

CONTENTS

FOREWORD

Bethel Township in Delaware County, Pennsylvania, was incorporated in 1683. It was one of William Penn's earliest and smallest townships, originating as part of Chester County.

Bethel Township is situated on the geological fall line that runs in a southwest-northeast direction across the length of the township. This is the high ridge that Foulk Road travels. To the east are the Coastal Plain, the Delaware River, and a view of South Jersey, and to the west are the fertile fields of Pennsylvania. The southern boundary with the state of Delaware, established in 1701, is a circular arc, which is unique among state lines in the United States.

The local forest contained a variety of trees. Yellow poplar, American chestnut, and white oak were used for the construction of buildings, and black walnut made good furniture.

In 1683, Robert Pyle, Robert Southery, Thomas Garrett, Joseph Bushel(l), and John Gibbons were among the first settlers in Bethel Township. They built both log and brick dwellings. Initially, they traveled between their homes by using farm roads that followed old Indian trails. In 1686, the Provincial Assembly built a road through Bethel and Chichester Townships. This road was later known as Bethel Road.

Villages developed in the new township. First, there was Chelsea, originally called Corner Ketch. Later, Booth's Corner and Zebleys Corner emerged.

For this book, many photographs were collected. These pictures depict residents posing and at work during farming, commercial endeavors, and even industrial enterprises. We are fortunate to have these photographs, some dating back more than 100 years. We are thankful that the owners of these pictures made them available. Finding and locating these photographs was a laborious task.

Many of the scenes and activities depicted here have long ago disappeared, especially the numerous farms with their surrounding stone walls, which served as property boundaries and also divided the fields. Gone are the stone farmhouses and large stone barns that dotted the landscape. Gone also is the Bethel Springs Water Company, which made shipments of freshwater to the resort areas of South Jersey. Gone also are the garnet mines. Garnet sand from these mines was shipped to New York to be manufactured into high-grade sandpaper.

At least three blacksmiths worked at one time in Bethel. A furniture- and coffin-maker was located at Zebleys Corner, and there was a wheelwright at Chelsea.

Benedict Field, a general aviation airfield, was at the site of the present Buckeye/Laurel Pipe Line Companies.

Most of the original settlers were Quakers. They held regular meetings and schooled their young at home. Later, in the 1800s, the Methodists came to Bethel Township and eventually gave rise in 1852 to the Siloam Methodist Church. Public education came to the township in the early 19th century.

Thanks go to all the people whose efforts made this book possible.

—Mead Shaffer
Bethel Township Preservation Society

ACKNOWLEDGMENTS

We offer our sincere appreciation and thanks to all who helped compile this history of Bethel Township, Delaware County. This book was always the dream of Reece and Mary Thomas, who passed before this book became a reality. Special thanks go to their family, who were quite willing to share all that the family had collected and archived in order to make this book possible. The Bethel Township Preservation Society, of which the Thomases were a part, has come alongside in gathering the photographs and the family histories. This book could not have been written without the invaluable resources of *History of Delaware County, Pennsylvania*, by Henry Graham Ashmead, written in 1884; *Bethel Township Thru Three Centuries*, by George Walter Goodley; and the 1984 *Historical Survey of Bethel Township* compiled by Nancy Webster. Special thanks go to Josephine Schott McDaniel, Douglas Baxter, Phyllis Baxter Wolffe, Jean DiMedio, Paula Blessley, Lura "Judy" Conner, Lois Campbell Pennington, Catherine McLaughlin, Larry Donahoe, Darree Clark, Donna Silvestri Fecondo, Denis Pandelakis, Sam Layne, and Romaine Trump Jones, who contributed heirloom pictures from the past, their families, and their youths.

Thanks go to Mead Shaffer, Janet Goldhahn, Geoffrey Gross, Jay Childress, and Paula Blessley for seeking out photographs and getting them to the point where they were usable by Arcadia Publishing.

A special thank-you goes to Keith Lockhart of DelawareCountyHistory.com who provided his knowledge from the research he is compiling on Delaware County one-room schools and his massive archival collection.

Special thanks go to the family of Bill Haley, who let us in on the personal side of Haley's life and his time spent in Bethel Township.

We hope this book will spur on people to collect their family histories and pass them on so that a second edition of this book can be compiled.

Unless otherwise noted, all images in this book appear courtesy of the collection of Reece and Mary Thomas.

INTRODUCTION

Bethel Township has a rich history, including mining, manufacturing, and even mushroom growing. First settled in the late 17th century and referred to as Bethel Lyberty—*beth el* is Hebrew for "house of God"—the hamlet had a number of Swedish settlers. In fact, the structure of a farmhouse believed to be Swedish in origin and around 300 years old still exists at the time of this writing behind a more modern farmhouse of the 20th century.

Bethel has played its part through American conflicts since the Revolutionary War. According to local historians, Continental soldiers marched past the local blacksmith on their way through town. Bethel's sons and daughters have participated in these occasions with fortitude and valor, some becoming high-ranking military personnel, like members of the Clayton family.

Stories of Bethel residents are quite varied; some residents were well-known political figures while others are thought to have aided slaves traveling on the Underground Railroad. Some have brought pleasure to the masses through their musical talent, and even a few local businesses have become renowned in the region and are visited by thousands of people. Booth's Corner Farmers Market, or as locals refer to it, "The Sale," is a market full of shops that people from all over the area visit. Images provided in this book, by both the residents who remain and others outside our town with deep connections to it, depict the residents, homes, businesses, houses of worship, schools, and many other significant aspects of this small township.

One

HISTORICAL FIGURES AND HOUSES

The historical people and houses of the township are what together make Bethel Township significant to American history. Various houses have been built on this land since the late 1600s. Research has shown that the first settlers of the township were Swedish, and while no photographs exist from that time period, the remnants of one of their structures do exist. The images in this chapter depict houses created throughout the 1700s, 1800s, and 1900s.

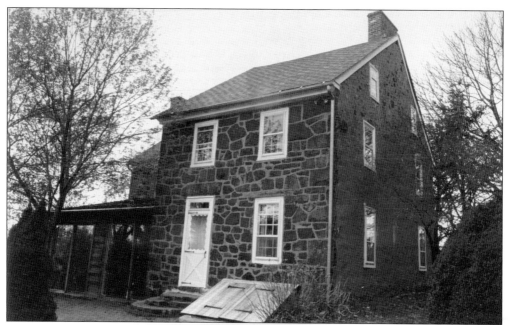

The Booth family kept the farm into the 1830s. In 1864, after several ownerships, the Cheyney family bought it and farmed it for over 100 years. Many of the following photographs include members of the Cheyney family and show life on the farm as it took place over the years. The Garrett-Booth-Cheyney home is shown here.

Pictured is the present-day main entrance to the Garrett-Booth-Cheyney home. The two-story farmhouse was built in 1721 with a second section constructed in 1810 on the foundation of an earlier log house. There are large open fireplaces that were used for cooking, and when the newest addition was erected in the 1980s, a working beehive-style oven was included. Today, a working sheep farm is located here.

Charles Mifflin Cheyney was a prominent citizen in Bethel and lived on Sarum Farm. Sarum Farm was the name the Cheyneys gave to the Garrett-Booth-Cheyney homestead. Charles Cheyney was a scout in the Civil War in Company F, 20th Pennsylvania Cavalry. (Courtesy of Romaine Trump Jones.)

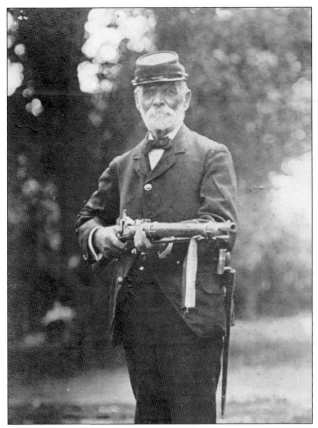

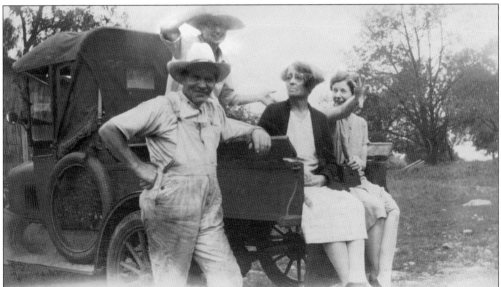

Pictured standing next to his truck is David Cheyney, with three unidentified people. David is one of the sons of Charles M. Cheyney. He lived on the farm and entertained a number of guests and family members. Judging from the vehicle, the date of the pictures appears to be in the 1920s. (Courtesy of Romaine Trump Jones.)

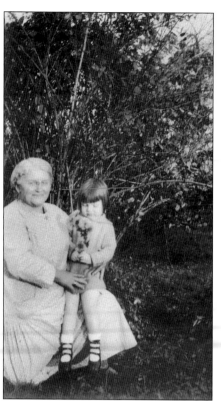

This is a picture of Louisa Ferguson (left) and Romaine Trump sitting in the garden at Sarum Farm. Louisa was the housekeeper for David Cheyney. She was employed after Cheyney's wife, Annie K. Cheyney (née Habbert), died at age 29 during childbirth. Romaine was the granddaughter of David Cheyney. (Courtesy of Romaine Trump Jones.)

This Federal-style house, located near the intersection of Foulk and Bethel Roads, was once home to some of the earliest settlers in the area, Booth family members. Note the arch over the door with fanlight transom window; at one point, there was a large wraparound porch. An icehouse was located where the new addition to the left of the house is seen. Many local places today derive their names from the Booths.

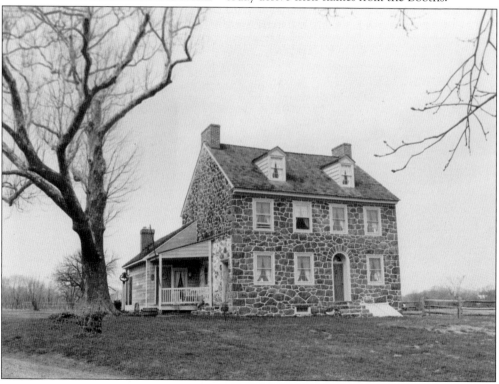

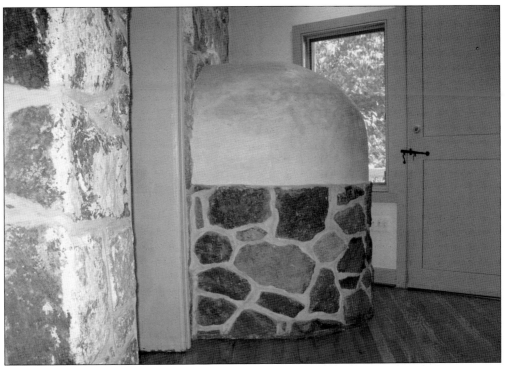

The interior of the Booth house pictured on page 12 has retained its integrity, and many of its details, such as fluted and reeded woodwork, candle cupboards, and enclosed winder stairs, can be viewed. When one enters the new addition, the most prominent feature is the rebuilt beehive oven. Until recently, this home was still in the hands of the original family.

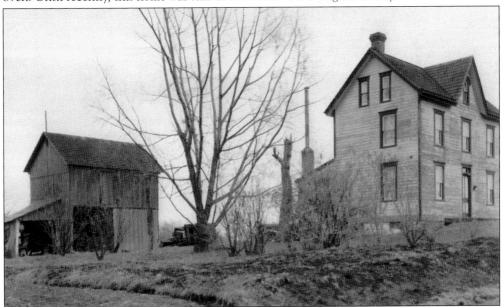

The Booth family owned many tracts of land throughout Bethel Township and the houses that were erected upon them. This home near the intersection of Garnet Mine and Bethel Roads was a Booth residence. Over the years, it has seen many improvements, which the present occupant enjoys.

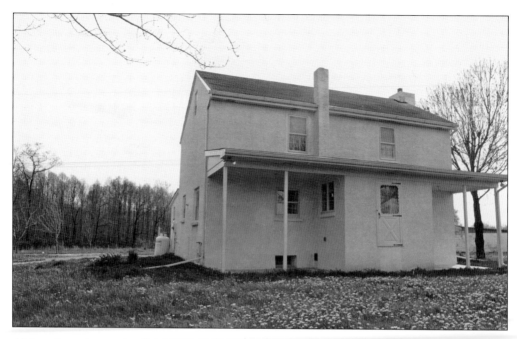

Although not impressive from the outside, this house located within the Greystone development is one of the oldest houses in the township and in all of Delaware County. Before the current development around it was built, the Gibbons house was said to be the oldest continuously lived-in house in the county. Originally, the house was 1.5-stories of Flemish bond brick, with the distinct possibility that the bricks were made locally. The house has many distinctive features that can be noted, such as the deep windowsills and curved plaster walls around the window openings.

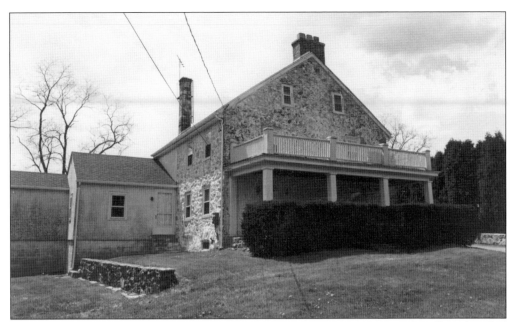

This is the front of the Poole homestead. It is located near the intersection of Foulk and Bethel Roads, and part of the property was given to build the Francis Harvey Green School. This is a fieldstone farmhouse, with the earliest part being erected in 1802. It was originally a two-story home with corner fireplaces on the second floor and a large first-floor hearth. This home stayed in the Poole family until 1913.

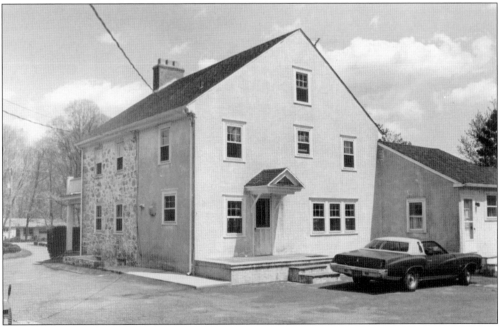

Two additions can be seen in this image of the back of the structure. The prominent stucco addition was built upon the older foundation, possibly from a former log house on the site. This was most likely the original site of the 1683 Bushel(l) house, one of the first settler homes in Bethel, as evidenced by early construction on the site.

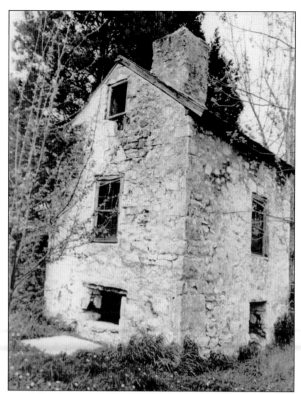

This springhouse was part of the Poole family farmstead. It was probably the original residence before the farmhouse was built and was later used as a tenant house. With corner fireplaces, the building is 1.5 stories and has a trinity layout, with one room above the other. It is banked to the east and has a water channel running through. Reconstructed around the year 2000, the springhouse is located on a tributary of the Middle Branch of Naamans Creek.

Located off of Garnet Mine Road on ground east of Spring Run, this Eyre house was demolished for the development of Garnet Ridge and Garnet Hills in the 1970s. The property was part of a Penn land grant to Robert Eyre, who was a prominent citizen at the beginning of Bethel Township in 1683; it stayed in the Eyre family until the 1850s. This farm had a mammoth stone barn that was in very good condition, and the sale poster from 1859 states that it could hold 30 head of cattle.

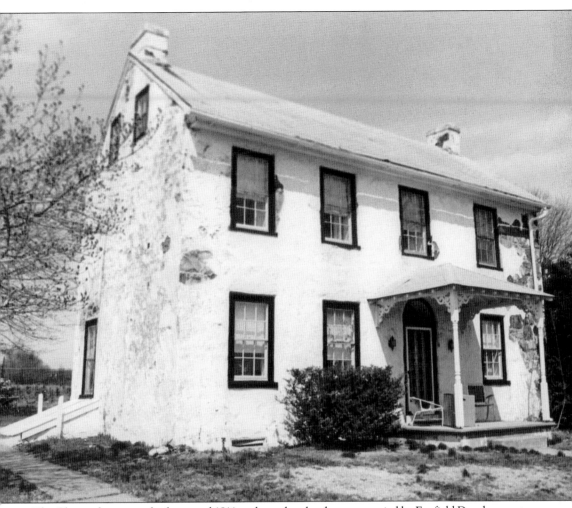

The Clayton house was built around 1811 and stood on land now occupied by Foxfield Development. It was a Federal-style house with a fanlight over the door. Sculptured ceilings and heavy molding were seen in the front stair hall. There was exquisite interior woodwork with excellent details. It is possible that Powell Clayton, an early builder in Bethel, did upgrades. This was home to Judge Thomas Jefferson Clayton (1826–1901), who was a lawyer and the presiding judge of the Court of Common Pleas for 25 years. It was also the home of Powell Foulk Clayton (1833–1914). Powell became a general in the Union army during the Civil War. After the war, he settled in Arkansas and became its Reconstruction governor.

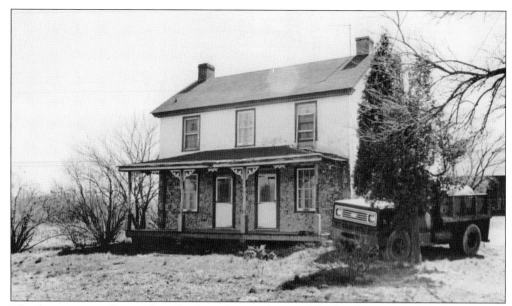

This home originally stood at Flat Iron Point, where Zebley Road and Naamans Creek Road intersect, until the road was changed to a jug handle. Interestingly, the road terms remain even though flatirons and jugs are no longer common household items. It was built around 1800 and has interior gable brick chimneys. The cornerstone on the barn, located on high ground off the west branch of Naamans Creek, has the initials *RP*, which could be for a Mr. R. Pyle.

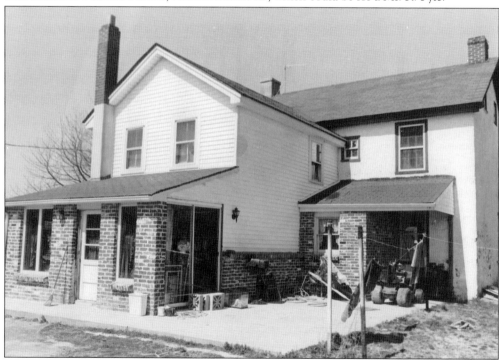

This home, which is the same as the one in the previous image, is now located in the Sweetbriar development for which the original acreage of the farm was sold. The frame addition at the back of the house was erected in 1870, and another addition was made to this in the 1980s.

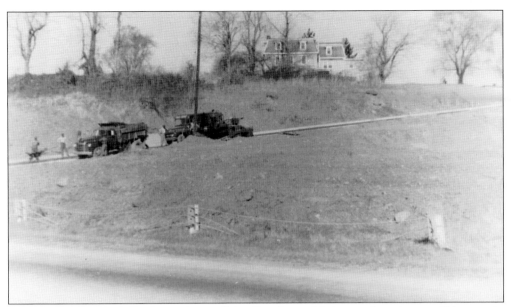

This mansion on the hill is located just off the Conchester Highway, where it can still be seen in the winter when the trees are bare. A stone, located on the second floor exterior, is engraved with the date 1756. This was a Larkin family home and was in the hands of the family for almost 150 years. In the beginning, access to the home was from a very long farm lane off of Larkin Road. The early Colonial features that are still evident are the foundations of three cooking fireplaces in the basement. As each addition was made, a new cooking fireplace was added. Over time, its appearance evolved from a Colonial to a Second Empire house with a mansard roof by the 1870s. It was during this period that the family was very prominent in local history. The former barn across the street was converted into a house.

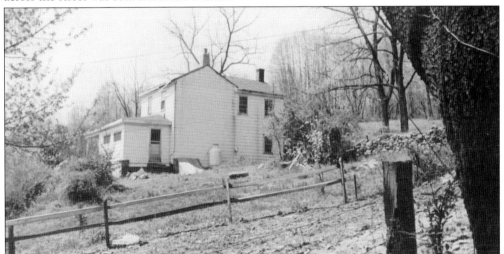

Located on Laughead Lane, this farm remained close to its original design until the 2000s. This frame trinity has experienced many changes since then. It is banked into the side of a hill and had an exposed spring. This farmhouse is over 100 years old and has a spiral staircase. When remodeling, the current owner found insulation made with horsehair. Although the residence has doubled in size, the original house with its unique details can still be found inside. When the side porch was removed, a brick-lined well was discovered, but it had to be filled in.

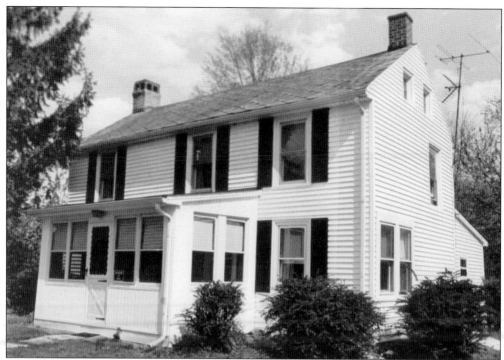

The original address of this property was Kirk Road, but it now stands on Linton Farm Lane. Encased in vinyl siding is one of the few remaining log houses in Delaware County. The trinity log house was built in the 1700s, with a large interior gabled chimney. The next section to be built was also of log construction; at that time, a stone with the date 1825 was placed. In 1875, this house was part of the Reece Baldwin farmstead, which consisted of more than 90 acres.

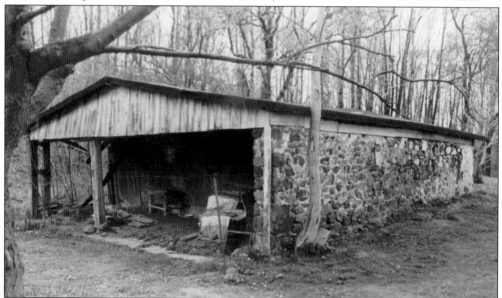

This is an outbuilding for the log house on Linton Farm Lane. The house is surrounded by brush, and the stone walls of this building can still be seen in the woods. This was the original bank barn when the stone first floor, stalls, and forebay were roofed over. The roof is now gone.

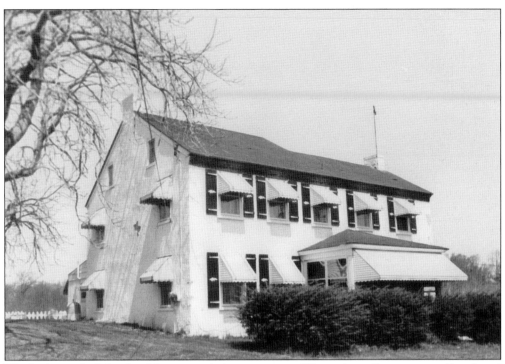

The limbs on the left side of the picture belong to a pair of Kentucky coffee trees, usually referred to as husband-and-wife trees, planted by the couple. This house is built in two sections, and the northeast section is considered the oldest. It was built according to the Penn plan. Today, the well is covered with clear plastic and is in the laundry area inside the house. This home has a large center hall. The current owner discovered the stairwell was placed over the top of the original staircase, which has been restored. The original address was on Bethel Road, and the current Goodley Road was the farm lane to this structure. William Goodley moved here in 1865 when he purchased the home from Lavina Clayton. Lavina built the Federal-style addition to the house in 1852; she was unusual for her time in that she never married and owned this property in her own right.

This early Colonial house is at the corner of Foulk and Concord Roads. With a general store and post office, it served an important role in the life of residents of Corner Ketch in Chelsea. At one time, it was known as Way's General Store, and the front of the 2.5-story building had three arched dormers and five bays. The architecture and interior detail of the store were such that it was bought and moved to Winterthur in the 1940s. The leaning cabinet formerly located here is on display at Winterthur Museum, Garden & Library in Wilmington, Delaware.

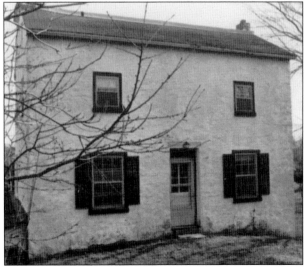

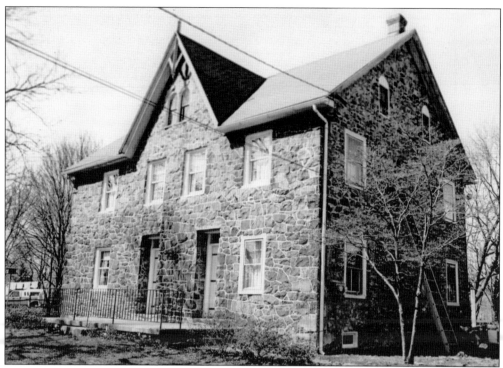

The Clayton Hinkson house was built before the 1830s on what appears to have been a paired Penn plan. When it was remodeled in 1850, the style attempted was Romanesque Revival. This style is conveyed with the use of a center hall and the cross gable with paired Roman arch windows. This was one of three dairy farms that would ship milk by train into Philadelphia.

This is a little stone outbuilding on the Clayton Hinkson farm. This structure is in the shadow of the house, and the 1984 survey states that it was a slaughterhouse with an icehouse cellar. When the property was sold in the 1970s, this building was incorporated into the house.

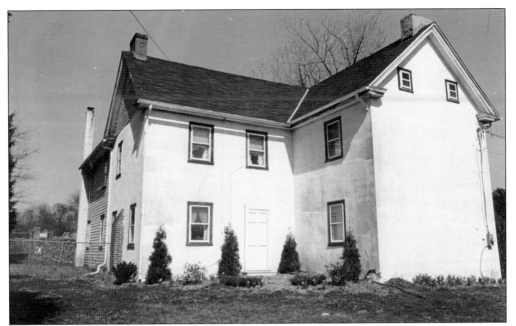

Known as the Cloud-Smith-Webster house, this residence is located on Zebley Road. This picture is interesting because it shows the front door. When the house was purchased in 1987, one could not find the front door inside because it had been drywalled over. The present owner replaced the door with a window in 1989. This house dates to about 1815, but a much older foundation supports the dining room. Outside, one can see a portion of the old wagon shed as well as some of the old barn's foundation.

This picture is the rear view of the home in the preceding picture. As one can see, there have been many additions. The part closest to the road is the original farmhouse owned by Foulk Cloud in the mid-19th century. It has three functioning fireplaces and thick masonry walls, which curve at many of the windows to allow in more light. There is random-width yellow pine flooring, and much of the original woodwork still exists. Some first-floor joists are sawn logs, and the bark can still be seen in the basement. There are winding stairs that lead to the attic. Additions were made in the 1930s.

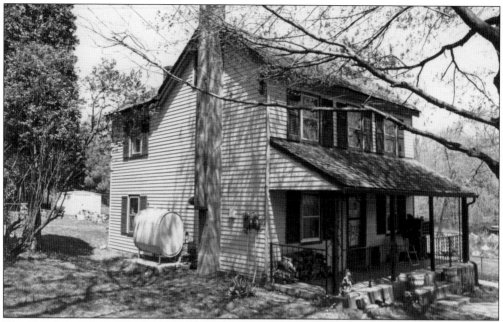

This farmhouse, located off of Laughead Lane, is known as Pine Grove Acres since a grove of pine trees has been planted in front and behind the house. It had its own private farm lane up a slight incline. It is a frame house with an open stairway in the living room, replacing a closed stairwell in the dining room. On this property, there are many outbuildings, but the barn has sadly fallen into disrepair. There is a small pond on the property that appears to be spring fed since it does not join neighboring creeks.

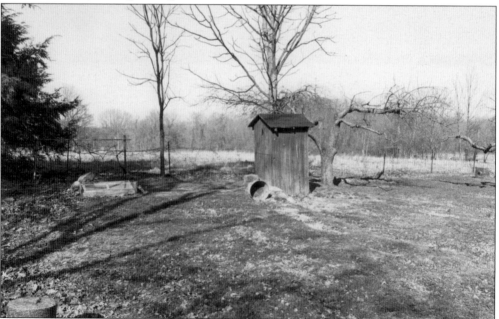

One of the most important outbuildings would be the outhouse. This outhouse, located at Pine Grove Acres, was probably decorative since it is located in the front yard. The original outhouse was located between the barn and the house, slightly set back from the kitchen door.

This home was originally on Garnet Mine Road across from Clayton Park. It was part of a 200-acre tract granted by William Penn in 1703 to the Gibbon family. Approximately 20 acres were sold around 1859 to Hugh Quinn, who built a house and barn. The barn was razed in the 2000s, and the original house was incorporated into the current house. The curve of the interior walls and deep windowsills reveal the age of the house. The grand staircase in the house is truly a sight to behold.

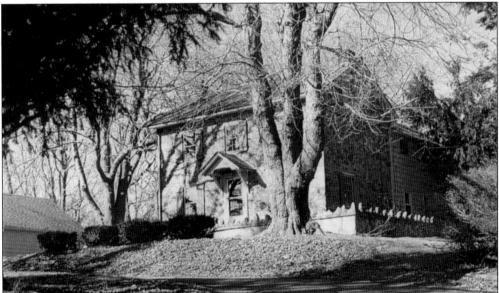

This is a wonderful fieldstone farmhouse in excellent condition, with much of its historical integrity restored. It is located on a sharp ridge above Green's Run. A stone wall borders the front leading into the house. The stone part of the house was built in the 1820s. There is believed to have been a log cabin on the site before that. The property was also part of the original land grant by William Penn to Edward Bezer; the Herman Behr & Co., which operated the garnet mines, later owned it.

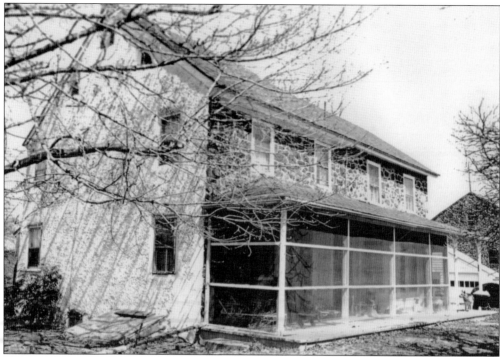

This was known as the Bergdoll house, which was named after the last owners. The front east wall that faced the Delaware River was constructed with Brandywine granite and was on the ridge of the fall line. The front of the house did not face the road but the river. This house was built in sections, with the southwest section started in the early 1800s. The next section had a date stone of 1882.

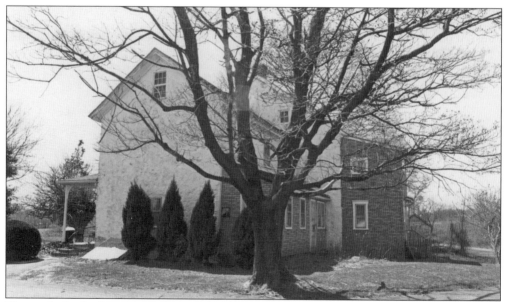

This is the back of the Bergdoll house (seen in the previous picture). It was situated on a farm of over 40 acres and was sold to build the development of the Hills of Bethel. The house and barn were demolished to make way for the new homes.

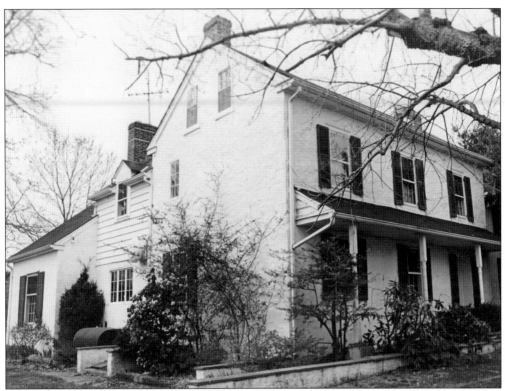

This house is interesting because it sits in both Delaware and Pennsylvania. The original farmhouse was built in 1840. It has original fireplaces and flooring and has the wide windowsills found in a house with thick stone walls. At one time, this house belonged to the Zebley family, which was prominent due to its connections to the store at Zebleys Corner.

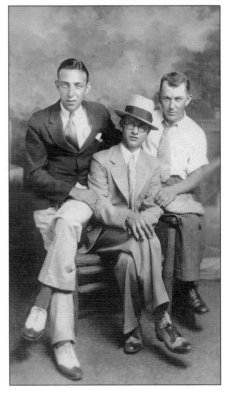

These dapper young men have decided to have their picture taken for posterity. They are, from left to right, Robert Halliday, Alfred Petit de Mange, and Richard Foulk. This picture was taken around 1930s. Alfred is related to the Zebley family through his mother and could have possibly visited the above home during his lifetime. (Courtesy of Larry Donahoe.)

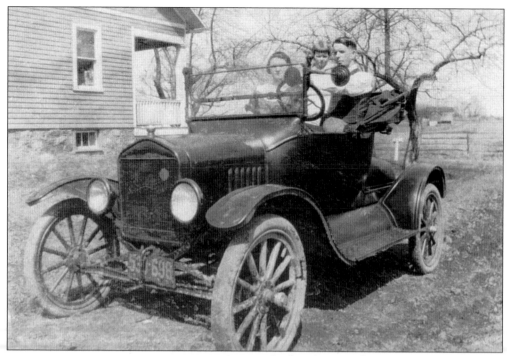

In this photograph, Harry and Bessie Petit de Mange Greenwood and their daughter Mae are sitting in their car outside of their recently built home on Zebley Road east of Foulk Road. The date of the picture is about 1924. (Courtesy of Larry Donahoe.)

Pictured at a house on Zebley Road around 1942 is Ida Banks. Ida's grandmother was Florence Petit de Mange. She married Harry Banks, and her son Harry Banks Jr. was Ida Banks's father. (Courtesy of Larry Donahoe.)

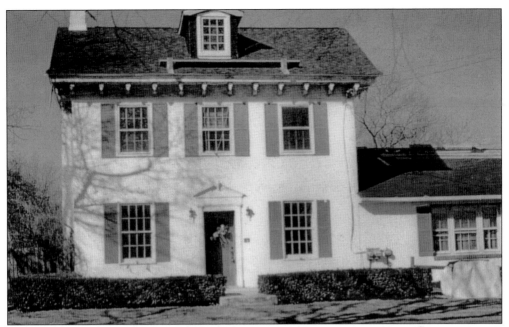

This was a small stone farmhouse that has been enlarged and remodeled. It appears as though the earliest structure was built around 1780. In the early 19th century, the house was changed to a central hall plan. In the mid-19th century, it was modified to have the appearance of an Italian villa. This style was rarely found in this section of Delaware County and reflects the influence of styles from the city coming to the country, as people made their summer residences their full-time abodes. The interior of this building has been greatly modified; it has been used as a business office and is currently used as a chiropractor's office.

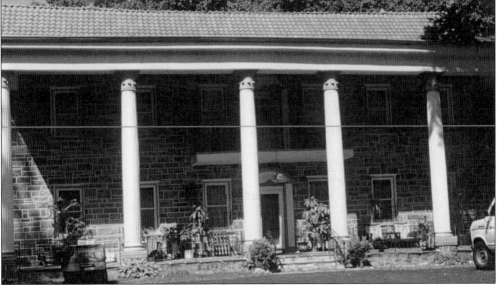

This is the front of Bella Vista, later known as Buena Vista. When traveling south on Foulk Road from Chelsea, one can see the house through the trees. Sadly, this mansion is slated for demolition in 2013 as its structural integrity has degraded to the point that it cannot be restored. A new development of homes is to be built shortly.

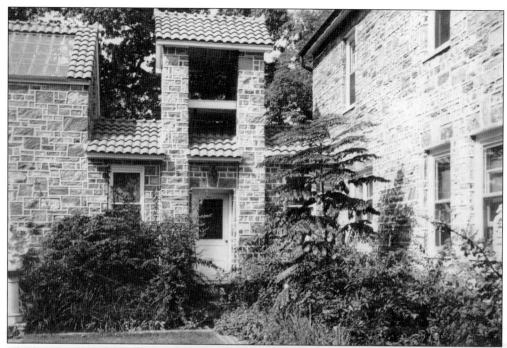

This mansion was built in the 1950s as the home of Dr. Joseph DiMedio. He was able to erect the structure by salvaging building materials from places, especially properties in Chester, that were being demolished. (Courtesy of Jean DiMedio.)

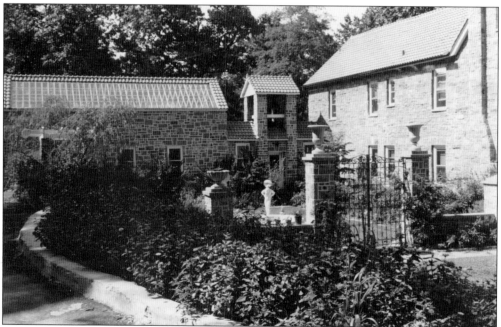

Dr. DiMedio named the property Bella Vista and did much of the work himself. It took two years to complete it. On the property were many statues that had previously been at the Medico-Chirurgical College in Philadelphia, which was demolished in 1916 to make way for the Benjamin Franklin Parkway in Philadelphia that leads to the art museum. (Courtesy of Jean DiMedio.)

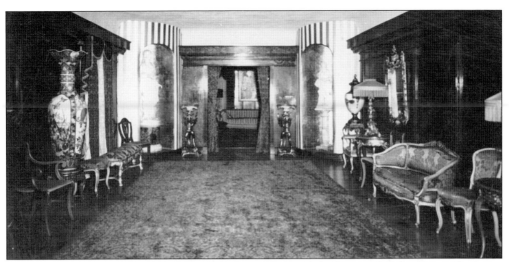

There were statues in the music room that formerly graced the home of Helen Kane. She was a singer and vaudeville actress who claimed to originate the "boop-oop-a-boop" phrase made famous by Betty Boop. Kane shared an amazing resemblance to Betty Boop, but lost her court case trying to prove that the character and catch phrase were based on her. A French vase in the room was used in the movie *Gone With the Wind*. (Courtesy of Jean DiMedio.)

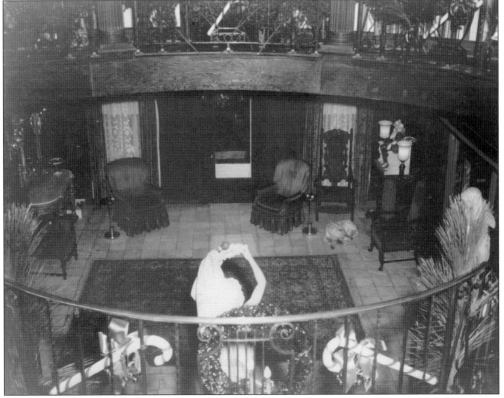

In this picture of Bella Vista, one can see the room under the huge dome. Dr. DiMedio constructed the dome when the project baffled carpenters. It was covered with gold leaf. (Courtesy of Jean DiMedio.)

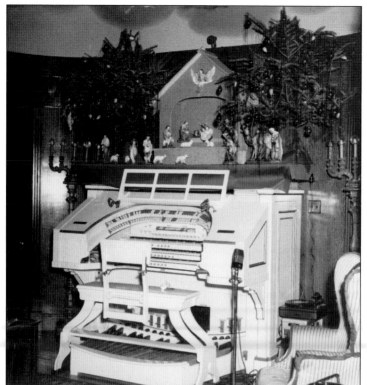

Also in the dome area was a pipe organ that the doctor got from a Main Line motion picture theater. The area was basically built around the organ and the space needs of all the interworkings of the organ and the large pipes. (Courtesy of Jean DiMedio.)

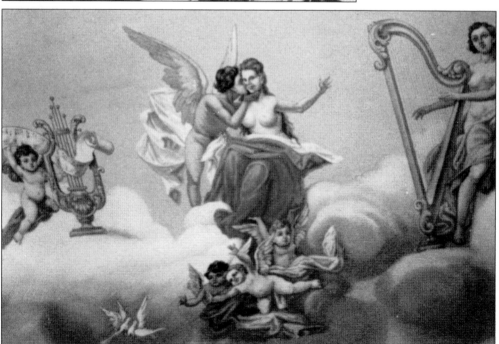

This is a view of one of the ornate ceilings in the mansion. Such artwork could put a person in the mood for classical music. Kathryn "Kitty" Forward, one of the later owners of the mansion, envisioned concerts being held there for her students at Chichester High School.

Two

THE LIFEBLOOD
OF THE LAND

Agriculture was the main livelihood of the people of Bethel in the beginning of its existence, and this is seen by the number of farms that were in the area and the number that still remain. The following pictures show little snippets of farm life and the wonderful barns that dotted Bethel Township.

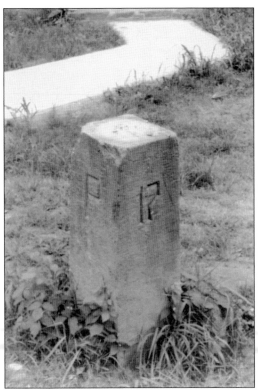

An important aspect of farming is to know where boundaries are. One of the most important local boundaries was the one between Pennsylvania and Delaware. This circular arc boundary is 22.6 miles long and has stone markers at half-mile intervals. On the north face of this marker, the letter *P* is cut into the surface. On the south face, the letter *D* is cut into the stone. On the east face is the date 1892, and on the west face is a number indicating which marker it is. Marker no. 17 is located off Ebright Road in Winterset Farms.

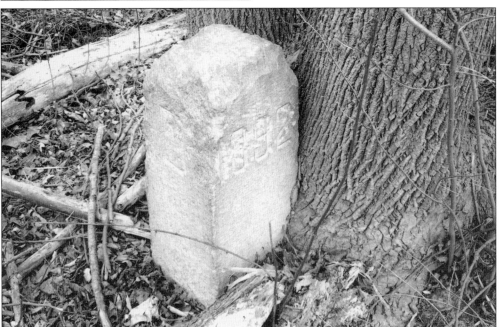

As they are the official property of the former US Coast and Geodetic Survey (now the National Geodetic Survey), these 12-Mile Circle markers are not to be disturbed. They are not only found in people's yards but also in the woods, hidden by overgrown brush. This marker, which has the year side exposed, is being consumed by a tree that is growing up around it.

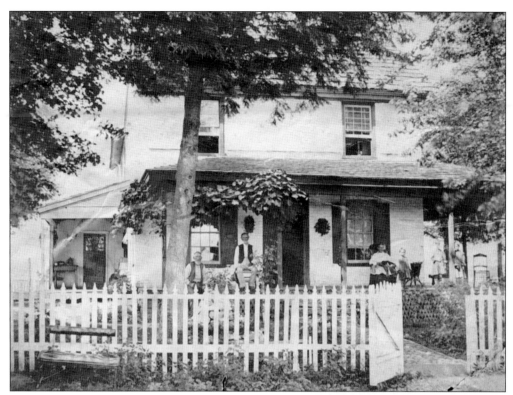

This is a stuccoed-over stone farmhouse. Previous owners can be traced back to around 1786. The farm belonged to Samuel Hewes (1819–1903) and was composed of 60 acres. This was a large dairy farm, and during the 1850s agricultural boom, many additions were made to the house. This was known as the McLaughlin farm until it was sold, and the property was developed into Longmeadow. (Courtesy of Catherine McLaughlin.)

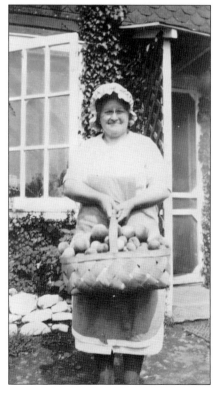

This is a picture of Gladys Coughenour, who lived across the street from Sarum Farm. She is holding a basket of peaches that were grown on Bethel Road. (Courtesy of Romaine Trump Jones.)

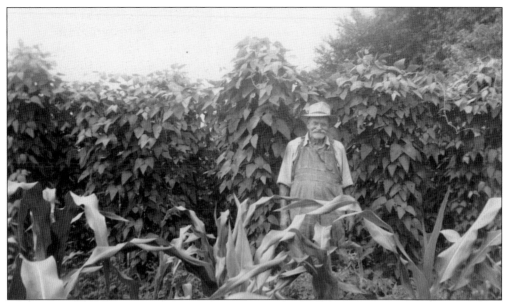

This is Dave Cheyney on the Sarum Farm in his vegetable garden. The lima beans are very high behind him, and the corn in front looks like it has a way to go, but when it is ripe, he most certainly will make succotash. (Courtesy of Romaine Trump Jones.)

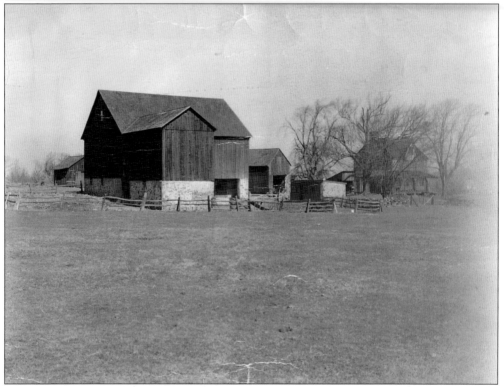

This picture of the Booth farm was taken from Foulk Road. The original barn predated the 1817 house, but there was a fire around 1900, in which the barn was destroyed; however, it was soon rebuilt. (Courtesy of Romaine Trump Jones.)

This path located on the Booth farm has a double stone wall and served as a cattle lane to various other lanes on the farm. The peach orchard on the left was behind the Booth farmstead, and this lane led directly to the wagon shed.

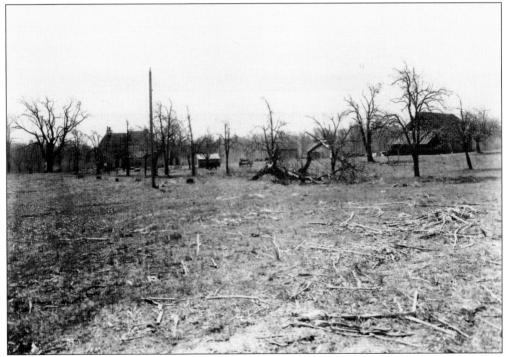

This farm was known as the Sutton Farm even though the Booths owned the property. It was quite a large farm, and its land was used for the current Bethel Springs Elementary School.

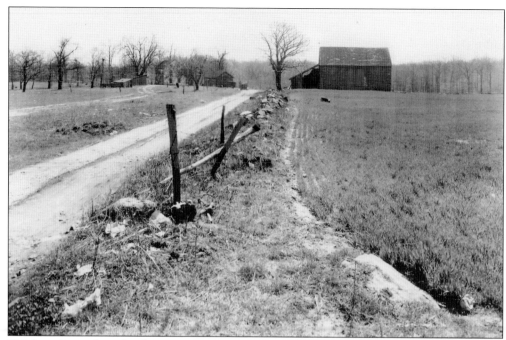

The barn located on this farm was pre–Revolutionary War. It was originally part of the Bushell land grant, which stretched all the way over to the intersection of Foulk and Bethel Roads. It was a wonderful barn, which burned in the 1970s and had to be demolished due to safety concerns.

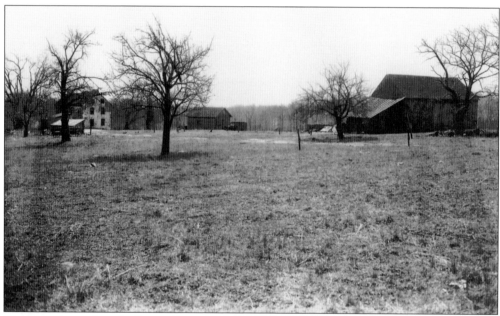

The house located on the Sutton Farm was very similar to the one on Sarum Farm, with fireplaces and heavy-duty shelving for fireplace utensils. The house was vandalized in the 1960s and had to be demolished. Each field on the property had a different name so as to be able to easily identify. Locals knew that the field referred to as "Frenchie" was rich with Native American artifacts. The Frenchie field was located due south of where Bethel Springs Elementary School stands today.

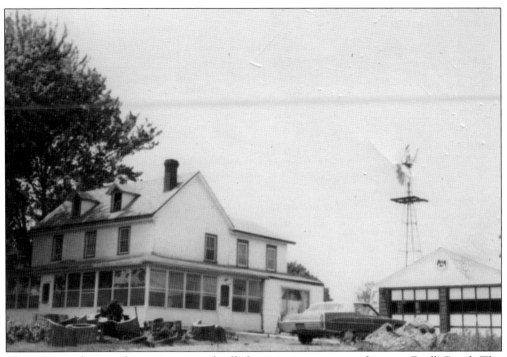

This picture shows a functioning windmill that was present on a farm on Foulk Road. The windmill was dismantled and removed in the 1970s.

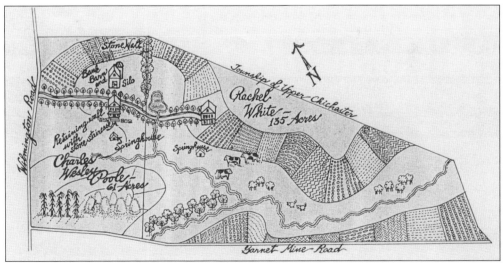

All developments did not take away everything from the past. When the Garnet Oaks development was being created, the developer, Realen, chose to make a nature preserve. This was called the Rachel White Preserve. It runs along the wetlands in the development and was named after a person who lived in the mansion with the mansard roof that can be seen from the Conchester Highway. The preserve also includes the ruins from the Clayton Wesley Poole farm. This area is now private property and is only accessible to residents of Garnet Oaks.

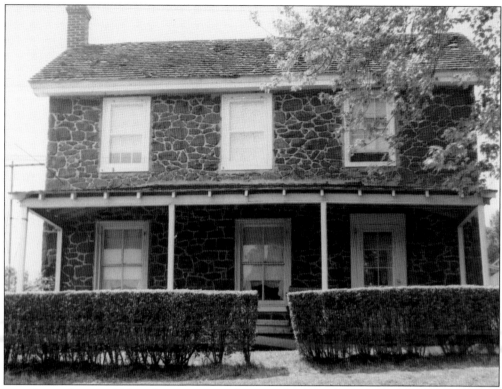

The Gaynor home, which no longer exists today, was where the Gaynors' dairy existed from 1923 to 1945. The business had to close because the Gaynors' son who drove the delivery truck was drafted into war. Additionally, regulations regarding raw milk were changing and becoming more restrictive, thus making it quite difficult to continue business as before.

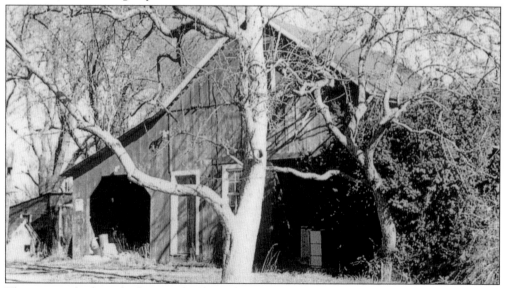

This wagon shed was built around 1860 and was located on the Powell property on Naamans Creek Road. It was found next to a bank barn, which was constructed around the same time. Both were demolished for the building of the Hills of Bethel development.

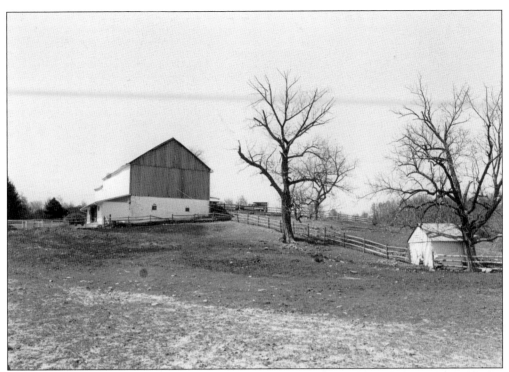

This was the large stone-and-frame Goodley bank barn off Goodley Road. The Goodley family owned the 100-acre property throughout much of the 19th century. The 1860s frame barn is gone, but current owners of the house Jon and Kim Briggs have lovingly restored the springhouse. The main house is located on the same property as the springhouse.

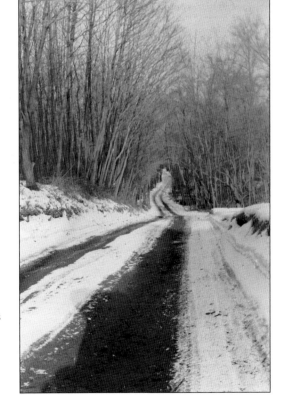

This photograph is of Laughead Lane in the 1990s, when, surprisingly, it was still a dirt road. The reason given to the residents was that it was a private deeded right-of-way and that those who lived on the lane were responsible for its upkeep. There were only eight houses on the lane at that time. (Courtesy of Josephine Schott McDaniel.)

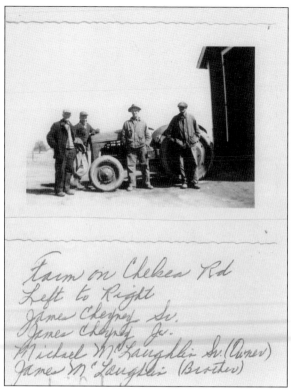

This group of friends is visiting on one of the McLaughlin farms; this farm was located in Chelsea. Pictured are, from left to right, James Cheyney Sr., James Cheyney Jr., owner of the farm Michael McLaughlin Sr., and his brother James McLaughlin. (Courtesy of Catherine McLaughlin.)

Farm on Chelsea Rd
Left to Right
James Cheyney Sr.
James Cheyney Jr.
Michael McLaughlin Sr. (Owner)
James McLaughlin (Brother)

This is a small barn hidden off of Laughead Lane. It was situated up against a cart trail, and on the far side were woods out to Foulk and Garnet Mine Roads. In the late 1930s, the farm had at least three cows, a couple of steers, and a pigpen. There were always chickens, as the owner would get 100 chicks every spring. Sadly, the barn has collapsed.

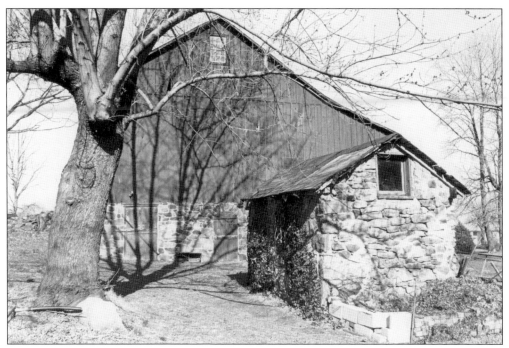

The coffin- and cabinetmaker of Zebleys Corner, a Mr. Larkin, was the builder of this finely constructed barn. A small open sawmill once operated between the house and the barn. A smokehouse is evident in the forefront of the picture

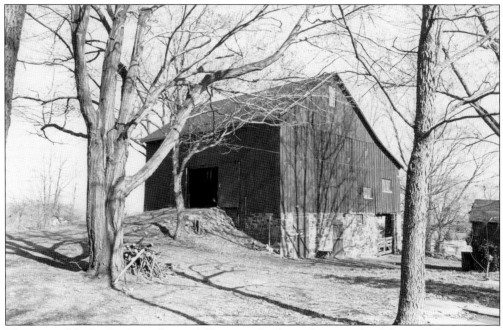

This view of the Larkin barn, from a different angle, shows that it is a bank barn, making it easier for animals to enter the lower floor and for farmers to store hay in the second level, which was still accessible by cart. This barn is located on a small knoll between Spring Run and the East Branch of Naamans Creek.

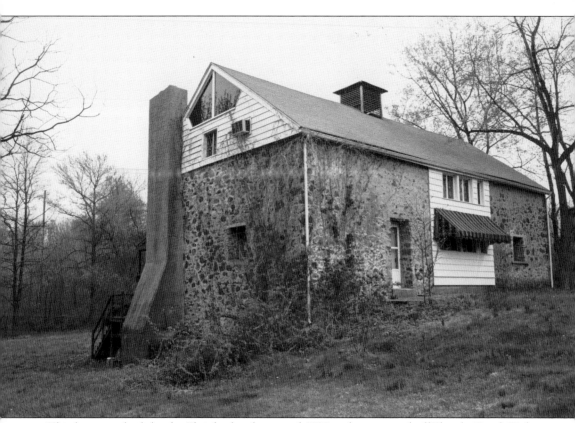

This barn was built by the Ebright family around 1780 and once stood off Ebright Road. Today, it is nestled in a development and can be easily missed if one does not know where to look. It is made of stone with post-and-beam construction. Many of the beams are numbered with Roman numerals. The reconstructed barn faces eastward for warmth for the animals during the sunrise hours. The barn has been converted into a house with all the modern amenities but has retained its charm. When visiting, one never forgets that he or she is in a building that was once a barn, with its high ceilings and the large window where the hayloft opening used to be. The owner states that hay can still be found in between the stones.

Three

CHURCHES AND CEMETERIES

Bethel Township started out as a Quaker community, judging by the number of residents who had been granted land by William Penn and the records found in nearby meetinghouses. Early meetings were held in the homes of local families, such as the Pyles and Bezers, who were some of the first settlers of Bethel. The Methodists came onto the scene in the late 1700s with the establishment of the first Methodist society in 1776 and Cloud's Chapel in 1780; after that, many people from Quaker families were then found on the rolls of the Methodist church.

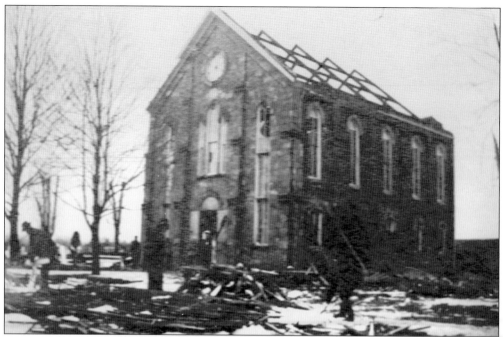

This is a picture of Chester Bethel Methodist Church. Though there are only two structures built specifically for religious purposes in Bethel Township proper, this church required inclusion in this section despite its location slightly outside of the township line. Originally known as Cloud's Chapel and built in 1780, the church pictured was the first Methodist church erected in the area surrounding Bethel Township. (Courtesy of Larry Donahoe.)

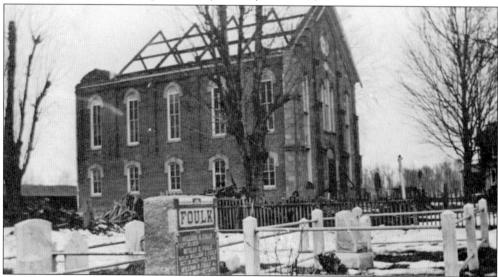

Significantly, this picture of the church is from when a storm blew off the roof in the late 1800s. The founding members of the Siloam Methodist Church, one of the two religious structures actually built in Bethel proper, were originally members of this organization, having broken away in the late 1840s. The pastor had purchased hymnals and organized a choir, but the older members of the church did not want singing as a regular part of their service. This cause a split in the church, and Siloam Methodist Church was the result. (Courtesy of Larry Donahoe.)

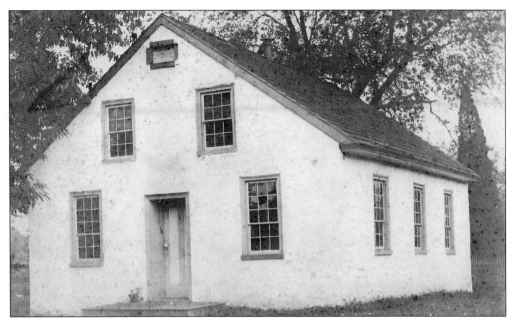

The first religious building in the Bethel was Ebenezer Chapel. Located on what is now known as Concord Road, it was built in 1846 by Dr. Phineas Price and served the spiritual needs of the residents of Chelsea. This little chapel was a mission chapel of Chester Bethel Church. It soon lapsed as such and was listed as a residence in 1848. In 1871, it was taken over by the Siloam Church as an outreach. Inscribed over the doorway is "Ebenezer Methodist Protestant Church A.D. 1846." Services were held until the 1920s. The church even had a cemetery to the back of it, but the people from it were reinterred at the graveyard at Siloam United Methodist. (Courtesy of Sam Layne.)

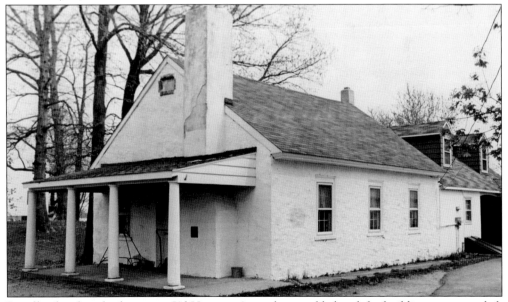

Locally, the chapel is known as L'il Heaven. A porch was added and the building was extended. The chimney pictured is not original to the structure, but there is a small brick interior chimney at the opposite end of the building that is. (Courtesy of Josephine Schott McDaniel.)

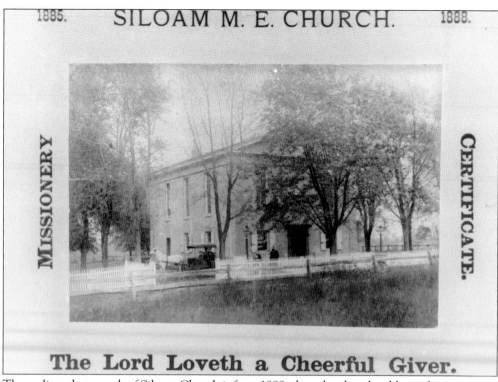

In the image (certificate): **1885.** SILOAM M. E. CHURCH. **1888.** MISSIONERY CERTIFICATE. **The Lord Loveth a Cheerful Giver.**

The earliest photograph of Siloam Church is from 1888 when the church sold certificates to raise money for its missionaries. Subscribers were given an 8-by-11-inch certificate to remind them of the missionary they were supporting that had gone out from Siloam.

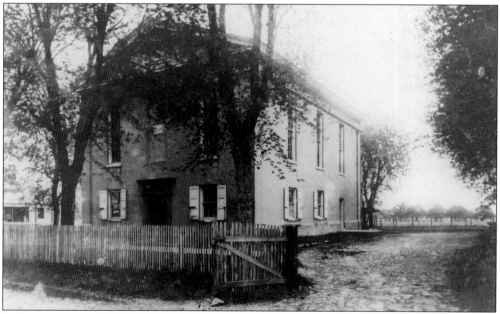

In this early picture of the church, it can be noted that the picket fence remains but is no longer white. There are still shutters on the first-floor windows. In the early 1900s, a peach orchard stood where later an addition to the cemetery would be.

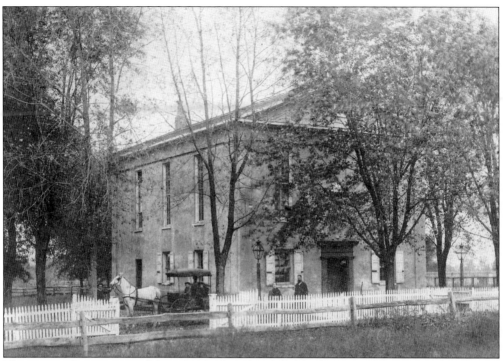

This picture shows a time at Siloam Methodist Church before the automobile became the common mode of transportation. One can see how narrow Foulk Road used to be.

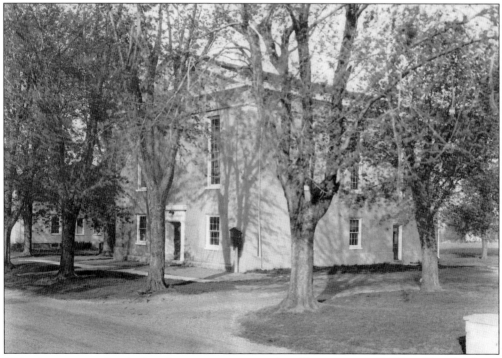

This picture was taken before the cemetery was enclosed by a stone wall. The old picket fence has been removed. One can see the proximity of Foulk Road to the front door.

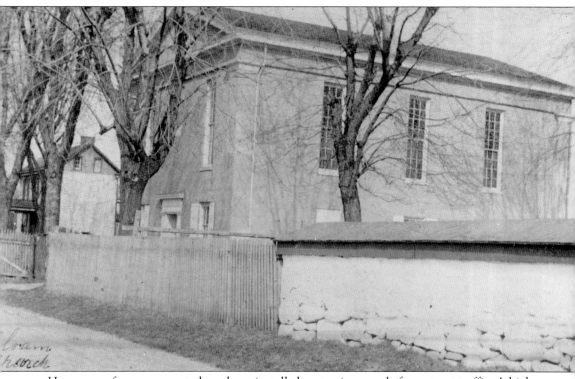

Here, a new fence appears to have been installed protecting people from street traffic. A higher whitewashed stone wall now encloses the part of the cemetery facing Foulk Road. One of the trees that lined the side of the building is gone.

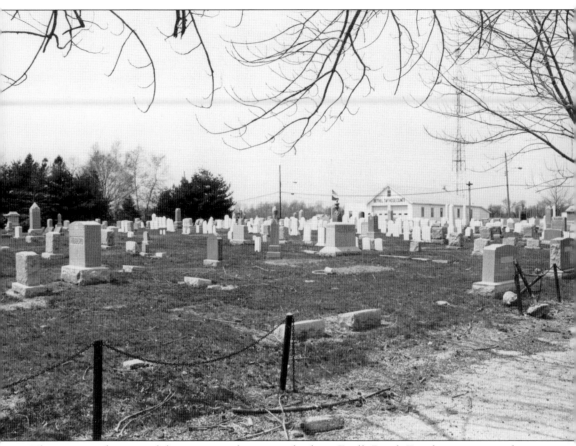

This is an early view of the cemetery facing south along Foulk Road. For the most part, this section is full, going up to the property line of nearby houses. The cemetery was expanded out to the west in the back of the building.

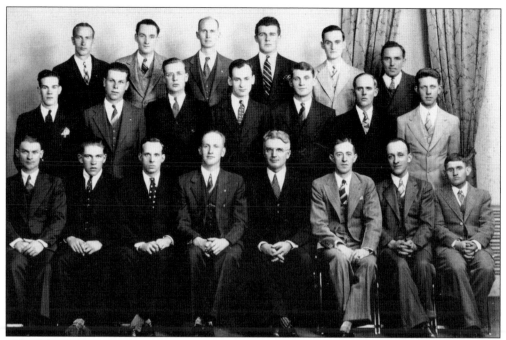

Pictured is a men's Sunday school class. Goodley's book mentions that many men came from Siloam and went into service either as pastors, lay pastors, or missionaries. The men in the Sunday school class are, from left to right, (first row) four unidentified, William H. Dutton III, Leman Zebley, unidentified, and Earl Phillips; (second row) Frank Gray, John Heacook, Pete Mangold, unidentified, Emerick Zerbe, Jim Hutton, and unidentified; (third row) three unidentified, Harry Kailers, unidentified, and George David Jewel.

This 1933 picture of the "The Wide Awake Class" was taken across the street from the church at Mary Booth's house. The teacher at that time was Rev. E.R. Elliott. A class by the same name was still being held in 1952, but at that time, Daniel Wiggins was the teacher.

Various township functions were held in this hall including local school graduations, as depicted in this image. Specifically, it is Bethel Township's eighth-grade graduation ceremony, held at Cloud Memorial Hall in June 1944. Pictured, from left to right, are (first row) Grace Thompson, Nellie Hare, Dot Zebley, Doris Parks, Joan Paris, and Anna McLaughlin; (second row) Kathryn Connor, Rodney Woodworth, Betty Booth, Ruth Smith, Tom McDaniel, Judy King, and Lila Davis.

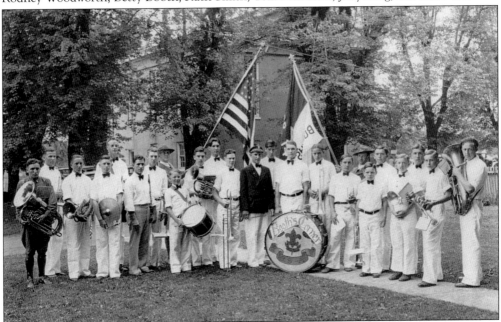

This is a Boy Scout band that was sponsored by Siloam United Methodist Church. The band members have been identified as, from left to right, Jewel Davis, Harry Kailer, Harvey David, Taylor Zebley, Howard Zebley, two unidentified people, Paul Zebley, Irwin Talley, unidentified, Harry Smith, Frank Gray, Willard Boudwin, Barney Clark, Emerick Zerbe, two unidentified people, Edward Goodley, Tom David, Felton Neeld, George Giberson, and three unidentified people.

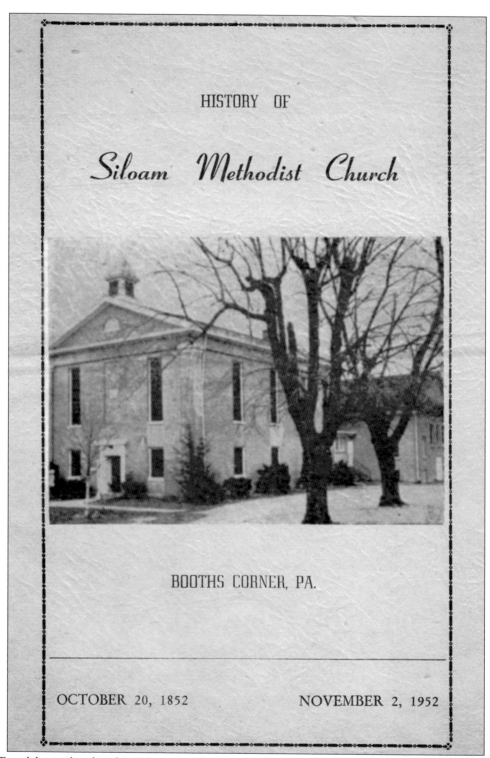

HISTORY OF

Siloam Methodist Church

BOOTHS CORNER, PA.

OCTOBER 20, 1852 NOVEMBER 2, 1952

To celebrate the church's 100-year anniversary, *A History of the Siloam Church* was written in 1952. (Courtesy of Josephine Schott McDaniel.)

Four

BUSINESSES AND SERVICES

Businesses have been essential to Bethel Township since the very beginning. The township is well known for Booth's Corner Farmers Market, and many other businesses have added to the cultural vitality of the town. From coffin-makers to mass mushroom manufacturing, the types of businesses have been endless. When a town has businesses and thriving populations, they begin to require various services from the municipality.

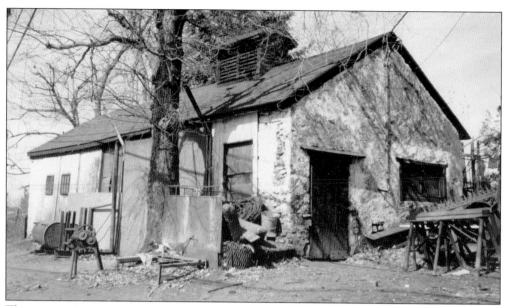

This picture shows the blacksmith shop located at the corners of Concord, Foulk, and Valleybrook Roads in the Chelsea section of Bethel, an area that is also known as Corner Ketch. Note the solid-wall construction of the shop. It is understood that this structure has been at this location since the 1800s and that a blacksmith has been found there since the time of the French and Indian Wars. According to town history, during the Revolutionary War, soldiers from the Battle of Brandywine passed it as they retreated to Chester on Concord Road.

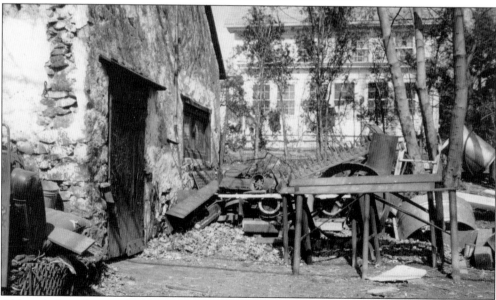

Although large by standards for blacksmith shops, there was not always room inside for one's materials. The overflow would be contained in the yard, but being on a small spit of land at a busy intersection did not leave much space. At one time, this was the longest-continually used blacksmith shop in Delaware County. In the 1980s, the shop was shuttered, and the operation moved down the street to a larger facility. It is still run by the same owners, the McKinleys, and is known for its metalworking and welding.

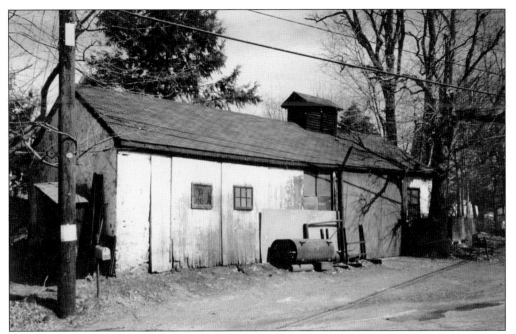

In this picture of the McKinley Blacksmith Shop, one should note the outhouse to the left of the structure. One can also see how close the road was to the front of the building. This spot was a school bus stop, and on cold winter days, the fire in the building could warm children waiting out front for their school buses. Sadly, this building was demolished in February 2013.

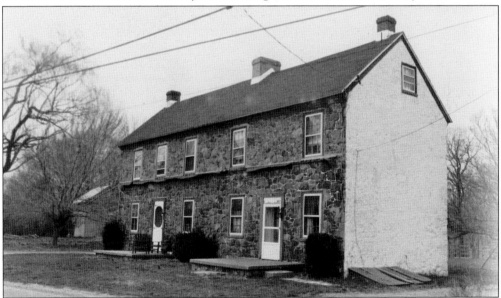

One of the most important businesses in Bethel, located at the intersection of Foulk and Zebley Roads, also known as Zebleys Corner, was that of a cabinetmaker, who also constructed coffins. It is said that his workshop was on the second floor and that he had a trap door to lower coffins to the first floor. As was typical of a house of that time, the cabinetmaker's residence had two front doors. One is noticeably wider than the other for obvious reasons. The building is said to have been built by the Cloud family in the early 1800s.

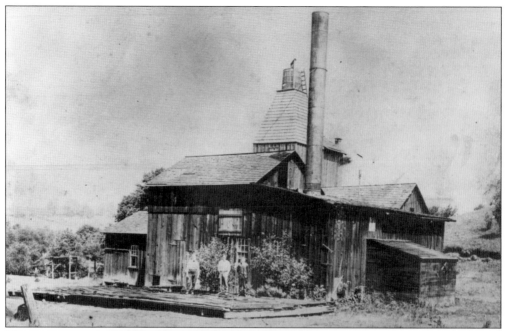

The garnet mines were built up around the turn of the 20th century. The first mine was located on the Lancaster farm; it changed hands and was then sold to Herman Behr & Co. of New York. It was determined that the garnet found in the mines was a quality that could be used for sandpaper. (Courtesy of Rick Nicholson.)

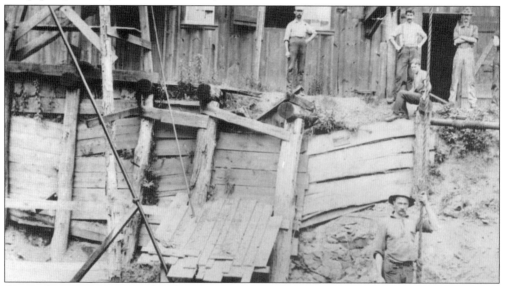

Over a dozen men were employed at the garnet mine, where they would work until the weather turned too cold and froze the pipes. This happened in the winter of 1900, when the pipes froze and subsequently ruptured, causing the garnet mine to close. Across the road from the location of the original garnet mine, another was started in the 1890s but did not last for long, closing in 1906. The garnet mines were filled in to make way for the building of the Conchester Highway, but mine remains can still be found near Clayton Park. Up until the 1960s, one was still able to find loose garnets in the streambeds in the area. (Courtesy of Rick Nicholson.)

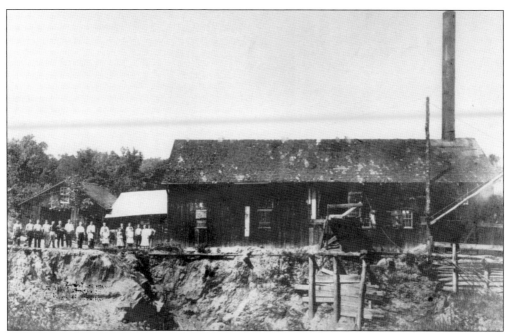

This image depicts how large the mine operation was and yet how few people were needed to run the plant. The garnet was mined here and then sent by train to either Troy, New York, or Massachusetts to be manufactured into sandpaper used for finishing off fine wood furniture. (Courtesy of Rick Nicholson.)

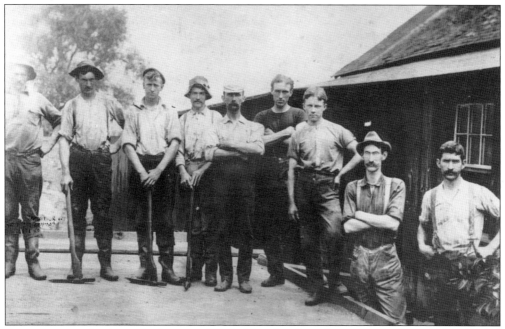

According to a book on the history of Bethel by Goodley, this image displays nine workmen who were operating the Bethel garnet mine around the year 1900. Apparently, at that time, only about 12 workers were required to successfully operate each mine. Shortly after this photograph was taken, the mines were closed. (Courtesy of Rick Nicholson.)

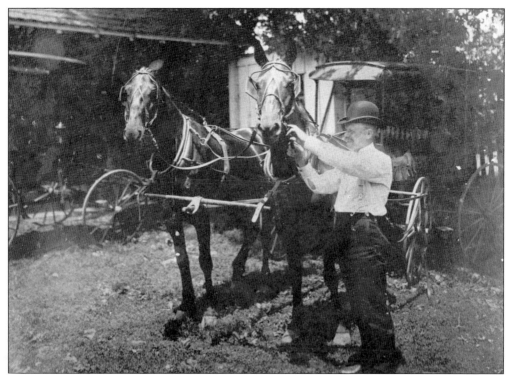

Another job that was necessary came about when rural delivery of mail was instituted. Bart Cheyney was one of the first mailmen in the area. He is seen here with his horse and buggy. Rural free delivery was started in 1896 and slowly spread across the country. In the past, people had to either travel to the post office or privately hire someone to deliver their mail to them. (Courtesy of Romaine Trump Jones.)

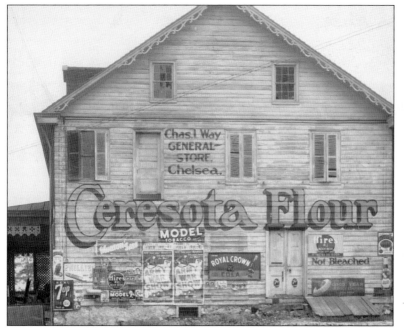

This is one of the earliest shops in the area, Way's store, which was located at the corner of Foulk and Concord Roads. Today, the store is totally gone, but the house that stood behind the store remains as a testament to things long gone, especially at this intersection of Corner Ketch. (Courtesy of Rick Nicholson.)

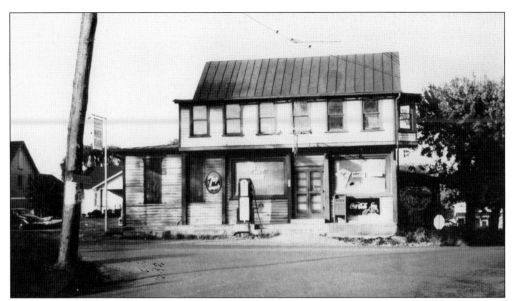

The store pictured was opened in 1835 and became known as Booth's Corner General Store. The time frame of this picture can be determined by the advertisements posted outside the store. One can see 7UP, Coca-Cola, Salada Tea, Abbot's Ice Cream, and White Flash advertisements. The gas pump and mailbox also hint to the age of the photograph, which is estimated to be from around 1930.

This is the rear view of the Booth's Corner General Store, which has seen many changes over the years since it was built in the early 1800s. Lord Jim Ferguson had an art gallery in the building at the time this picture was taken. The structure now houses a few businesses, and the front of the building faces the busy intersection of Foulk and Naamans Creek Roads. The original lock on the front door to the building can be found in the Bethel Township Preservation Society's Collection, housed at the John L. Myer Township Building.

Located at the intersection of Kirk and Garnet Mine Roads was one of the lesser-known stores in Bethel. At the time of this picture in the 1980s, a small food market was found here. This photograph of the rear of the building was taken heading east on Garnet Mine Road. The area surrounding the store is called Frogtown due to it being marshy. The store only occupied the right side of the building in what appears to be a later addition to the original house. The structure is now a private residence.

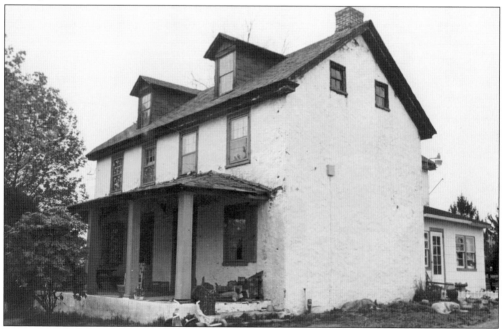

Behind this house were 15 acres of thriving apple orchards. Apples from the orchard were harvested and utilized in a local cider mill, which was also located behind the house. The home was built in 1852, and the cider mill began operating sometime after that. The cider mill operation continued up until 1974. (Courtesy of Rick Nicholson.)

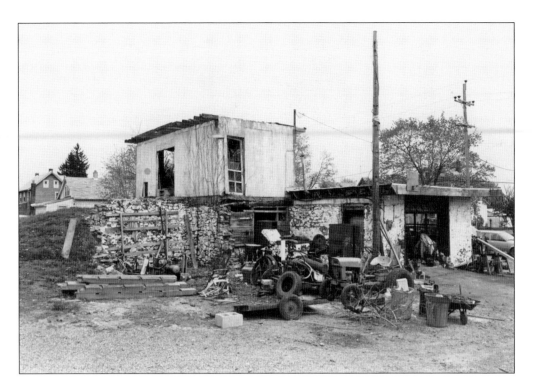

The Armstrong Cider Mill was a small business locally owned and operated by the Armstrong family throughout its existence. These images of the mill were taken after it had stopped operating for some time. Clearly, the debris around the facility would not have been conducive to business.

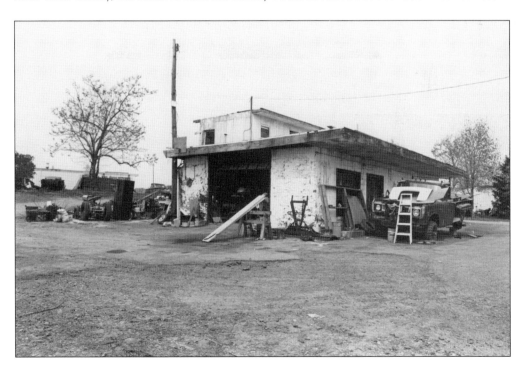

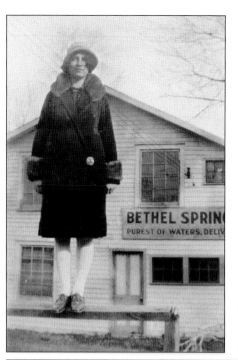

This is a very rare photograph showing the actual building where Bethel Springs water was bottled. The unidentified woman is standing on the fence rail. This photograph was most likely taken in the 1920s.

Although pictures of the Bethel Springs water plant are hard to come by, a bill from the company is not. Even the local school at Booth's Corner, which did not have running water, was charged for the water that was delivered to it. This bill appears to be from the month of February sometime during the 1920s, but an exact date is not noted on the invoice. Between 8 and 12 five-gallon bottles of water were delivered to the schools every two weeks.

USE ONLY BETHEL GUARANTEED DISTILLED WATER

PURE WATER	CLEAN BOTTLES	REGULAR DELIVERY

RING CHESTER **3688** XXXXX 5-1516 R. F. D. BOOTHWYN, PA._____192

Booths Corner School,

TO **BETHEL SPRINGS WATER CO.,** DR.

BILLS DUE WHEN RENDERED SPRINGS: BOOTH'S CORNER, PA.

| 1-6 | 12 | 5 gal. water | 23692 | 7 | 80 | | |
| 1-18 | 9 | " " " | 11857 | 5 | 85 | 13 | 65 |

ok - Ed

Please note —
New ice coolers have
been placed in each school.

13.65 B Corner
6.50 Chelsea
7.80 no 1
$27.95 — Total

YES WE SUPPLY DISTILLED WATER

Outdoor auctions, as the image depicts, were a simple and popular way for locals to dispose of their estates during the early 1900s. This particular auction was held on the grounds of Charles Slawter's home located on Foulk Road. Auctions were still being held in Bethel Township in two locations as of the 1980s; however, they were no longer on the individual's property but in a local auction house. Currently, Brigg's Auction is the only one that still operates every Friday night, weather permitting. (Courtesy of Larry Donahoe.)

This sign advertises Brigg's Auction north on Naamans Creek Road. William Gay and George Phillips began the Booth's Corner Auction on this site in 1932. The two went their separate ways, and in 1939, Gay sold his business to William J. Briggs. The auction firm has continued in the Briggs family since that time.

This picture shows the present state of the famed Booth's Corner Farmers Market. It has expanded and grown since it was totally devastated by a fire in 1973. The structure was rebuilt within two years and continues to thrive today.

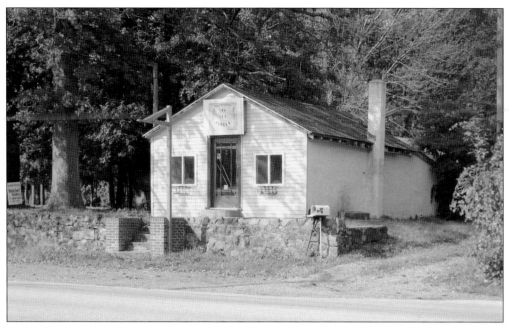

When the Booth's Corner Farmers Market was started in the 1930s, vendors had little booths for their wares. This shop saw many such businesses. At one time, it was an outlet for Eskil clogs, which took the country by storm. Eskil Gidholm, who lived in neighboring Glen Mills, had a store here. Before it was demolished to make way for the expansion of the farmers' market, it was the Ivy Garden, which was an eclectic store that sold a number of knickknacks and collectibles.

One of the most long-standing businesses in the community is the mushroom farm on Naamans Creek Road belonging to Joseph Silvestri & Son, Inc. Its one and only crop is *agaricus bisporus*, a white type of mushroom. (Courtesy of the Silvestri family.)

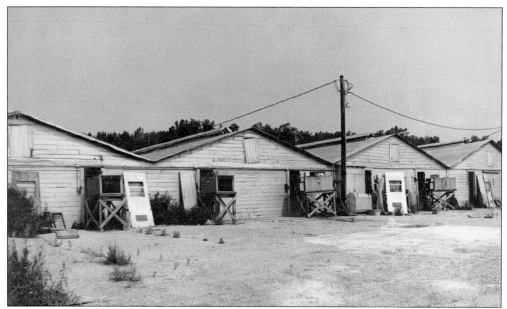

This is a photograph of the early Silvestri mushroom farm; it started with four growing houses in 1925. At the very beginning, there were eight employees. Someone has to be on the farm 365 days a year, 7 days a week, 24 hours a day. (Courtesy of the Silvestri family.)

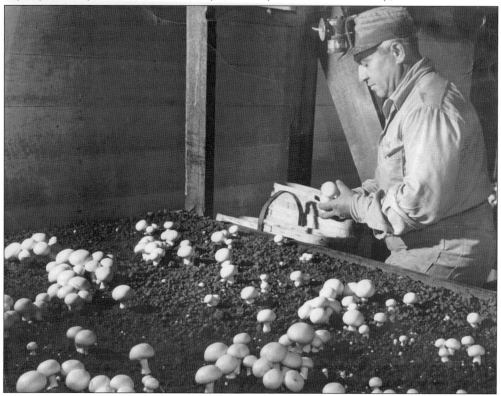

Mushrooms have to be watered, and the temperatures have to be checked on a regular basis as mushrooms are heated and cooled at the same time. (Courtesy of the Silvestri family.)

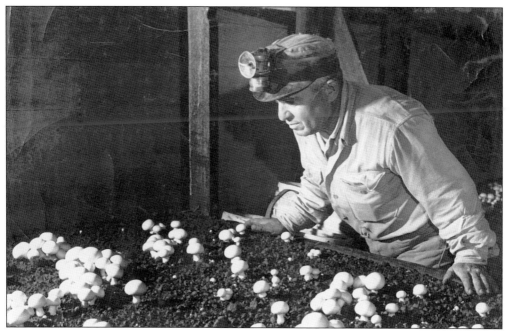

Mushrooms are inspected for quality and size. There are six different sizes of mushroom and twelve varieties of packaging. The taste does not change regardless of the size of the mushroom. In this picture, Joseph Silvestri is inspecting the mushrooms. (Courtesy of the Silvestri family.)

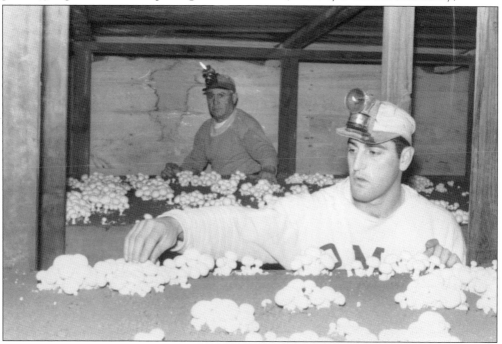

In this picture, Joseph Silvestri (background) and his son Gino (foreground) are managing the mushroom harvest. Silvestri mushrooms are known for their quality and high production. Donna Silvestri Fecondo is on the board of directors of the American Mushroom Institute. (Courtesy of the Silvestri family.)

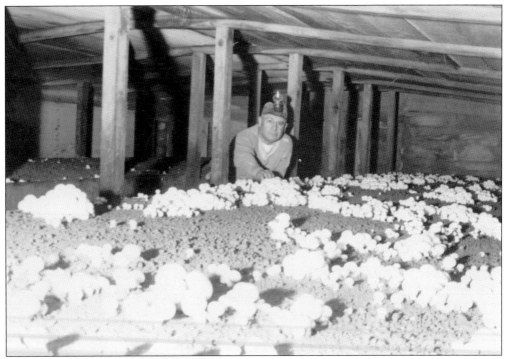

In this picture, one can ascertain how large the operation is. Each mushroom house has two levels and over 8,000 square feet of growing space on each level. (Courtesy of the Silvestri family.)

Today, there are five buildings with 42 single growing rooms of mushrooms. The farm is open for sale every day of the week from 7:00 a.m. until 5:00 p.m. There are currently 80 employees, with women harvesters on staff. Four generations of the family have worked on the farm, and plans are to continue this way in the future. (Courtesy of the Silvestri family.)

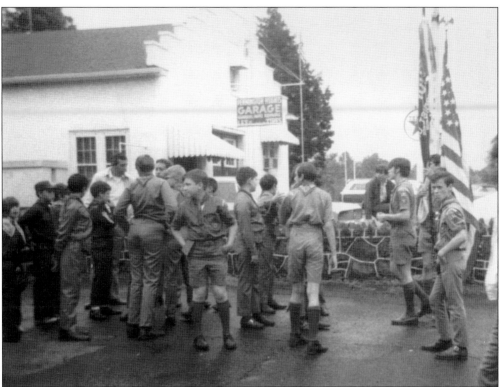

Here is Pennington Heights Garage, which is now known as Zuppo's Garage. The Boy Scouts appear to be getting ready for a parade. Today's Memorial Day parade route is very short. It goes from Brigg's Auction on Naamans Creek Road to Siloam United Methodist on Foulk Road. Judging by the cars seen in the background, this picture appears to be from the 1960s.

EXPERT REPAIRING
— OF —
AUTOMOBILES
QUICK - CHEAP - EFFICIENT
WE DO ALL KINDS OF REPAIRING, RENOVATING, TRUCKS AND MACHINES ALL WORK GUARANTEED

Telephone: Concordville 89-R-4 JOSEPH OSOWSKI, Proprietor

PENNINGTON HEIGHTS
BRIGHT ROAD AND NAMAAN'S CREEK ROAD BETHEL TOWNSHIP, DELAWARE COUTY, PA.
Post Office:
BRANDYWINE SUMMIT, PA.

FACHOWA REPERACJA AUTOMOBILOW
SZYBKO -- TANIO -- DOBRZE
WYKONUJE WSZELKIE REPERACJE, PRZERÓBKI AUTOMOBILÓW, TROKÓW I MASZYN

TELEPHONE: CONCORDVILLE 89-R-4 JÓZEF OSOWSKI, właściciel TELEPHONE: CONCORDVILLE 89-R-4

An advertisement for the Pennington Heights Garage proclaims everything the shop is capable of repairing. The advertisement even provides a Polish translation at the bottom. At the time, proprietor Joseph Osowski ran the Pennington Heights Garage.

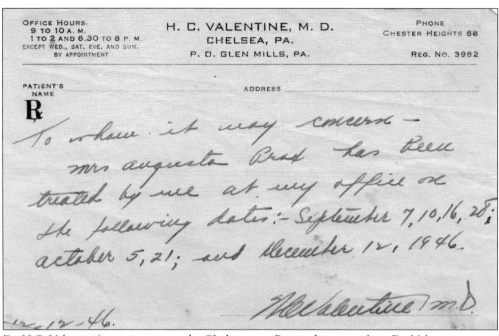

OFFICE HOURS:
9 TO 10 A. M.
1 TO 2 AND 6.30 TO 8 P. M.
EXCEPT WED., SAT. EVE. AND SUN.
BY APPOINTMENT

H. C. VALENTINE, M. D.
CHELSEA, PA.
P. O. GLEN MILLS, PA.

PHONE
CHESTER HEIGHTS 88

REG. NO. 3982

PATIENT'S NAME

ADDRESS

℞

To whom it may concern — mrs augusta Prax has been treated by me at my office on the following dates:- September 7, 10, 16, 28; october 5, 21; and December 12, 1946.

HCValentine, m.d.

12-12-46.

Dr. H.C. Valentine's practice was in the Chelsea area. Pictured is a note from Dr. Valentine stating the days that Augusta Prax came into his office for treatment.

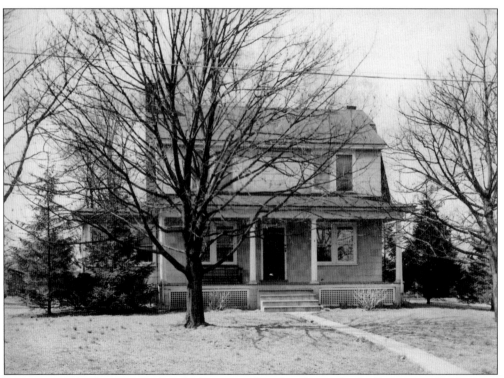

At one time, this house served as the location of Dr. Booth's medical office at Booth's Corners. The front room is still reminiscent of a waiting room.

The building shown here was called Redman Hall. The hall was used as an official meeting place for various local lodges. The Improved Order of Red Men and the Knights of Pythias Society met here for a length of time.

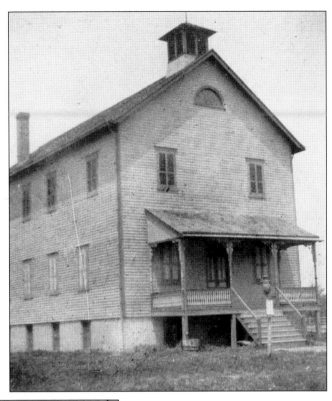

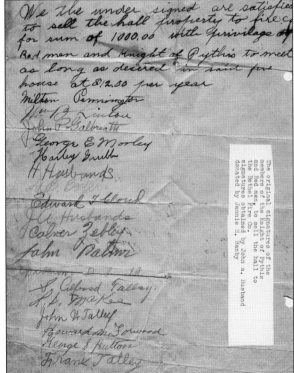

The original signatures of the members of the Knight of Pythias and Red men to sell the hall to the Bethel Fire Co. These signatures obtained by John A. Husband donated by Jennie H. Hanby

The building seen in the previous image was signed over to the firehouse—but not for long. The structure was also used as an overflow school building; however, during that time, it burned to the ground.

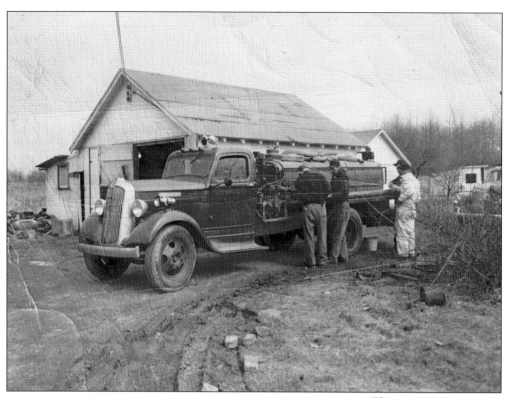

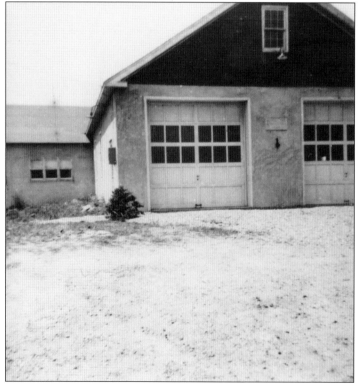

This c. 1945 photograph is of the first fire truck owned by the Bethel Township Hose Company No. 1. The fire hall was built on the property where the former Redman Hall stood.

This is a c. 1946 photograph of the Bethel Township Firehouse. It was taken before the addition of the first radio room, which can be seen in later images. The firehouse has since been renovated with new truck bays, a radio room, engineers' room, and a chief/officers' office. The first radio room was converted into a hall and is now a catering facility.

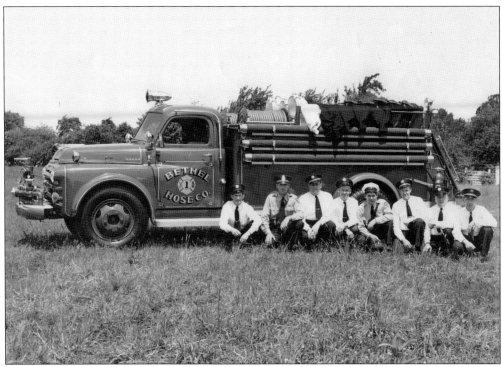

The number of fires in the township at major businesses and homes shows the importance of having a fire company. Bethel Township Hose Company No. 1 has been an integral part of the community since 1944. Pictured are, from left to right, firefighters Mit Husband, Pete Mangold, Chief John Heacock, Percy Farron, Charles Griffin, William Gray, Joe Osowski, and Jim Miller Sr.

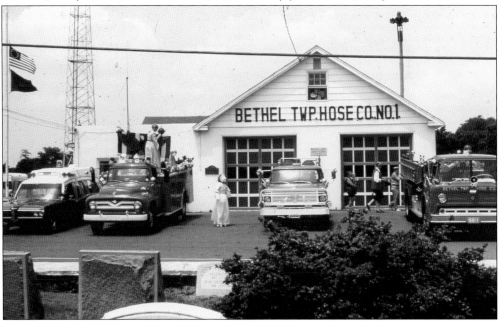

Taken from Siloam United Methodist Church, this photograph shows some of the older equipment that was used by the firehouse in 1976.

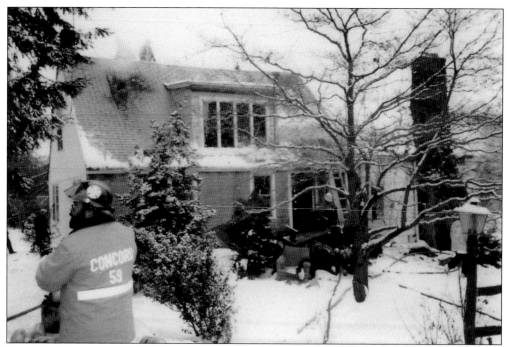

Here, local firemen are in action at a house fire on Garnet Mine Road. Sadly, the property, home of the Stover family, was mostly destroyed, and the contents of the house were lost.

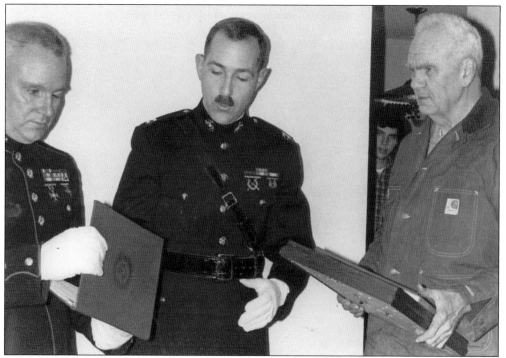

Bill "Smokey" Stover lost his medals in the fire; here, he is receiving replacement medals for his military service. Pictured, from left to right, are GySgt. John McDonald and Capt. Wayne C. Anderson of the First State Marines and Stover.

Five

SCHOOLS AND EDUCATION

There is a history of private schools in Bethel Township that existed before the Free Public School Act of 1834. The oldest school noted, according to a newspaper article in 1951, was one held in a springhouse north of Zebley and Foulk Roads. The early history of the second-oldest school in Bethel has also been obscured with time. However, the following information was obtained from the *Pennsylvania School Report*: On September 28, 1808, Caesar Pascal, a black servant of the Willcox family, sold an acre of land for $40 to four trustees, Ben Cloud, John Grubb, William Peters, and John Richards. The location of this school is uncertain but could have possibly been located at the corner of Concord and Chelsea Roads. The deed of the log structure on this land does not contain mention of its use as a school, and there is no subsequent deed record of when the property was sold. There is also mention of an octagonal school that was situated near the intersections of Foulk and Kirk Roads. Sadly, there is no modern record of this school. A thank-you goes to local Delaware County historian Keith Lockhart for providing more information on the schools of Bethel.

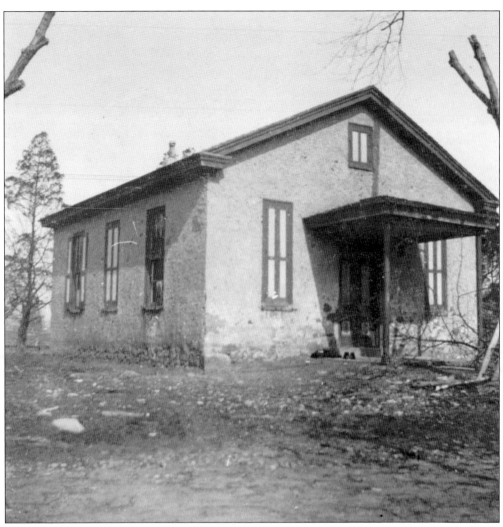

According to the *Pennsylvania School Report*, on September 25, 1820, Isaac Larkin sold a half acre of land to three trustees, Thomas Booth, John Larkin, and Nathaniel Larkin, to establish School No. 1, Bethel's first public school, on the southeast corner of what are now Bethel and Foulk Roads. This school was also known as the Central School. It is quite possible that the original school at this location was octagonal; however, whatever the shape, the building shown replaced it in 1868. Osborne Booth built the new structure at a cost of $2,661. The school was used until 1952 and was sold in September 1953 for $3,000.

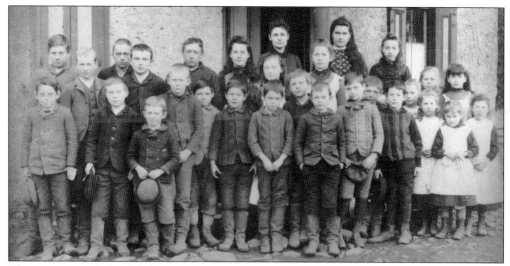

This is a group of schoolchildren by the side of School No. 1 in Bethel Township. Note the high-top leather shoes and pinafores the girls in the right of the photograph are wearing—this style of clothing helps to pinpoint the elusive date of this photograph. While not all children can be identified, a few are known. Pictured are, in various order, the future Dr. Thomas A. Booth, Sam Goodley, Reece Zebley, Ed Larkin, two Hamilton girls, Jennie McGlaughlin, and Bart Cheyney. According to the photograph, McGlaughlin is located near the window, and Cheyney is holding a round hat. Given that Dr. Booth was born in 1874, this picture was likely taken in the mid-1880s.

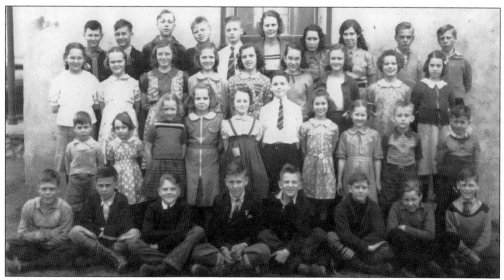

Students of School No. 1 in Bethel are pictured in 1939. They are, from left to right, (first row) Harold Folgolman, John Patasnik, Oliver Founds, James Stevenson, Irvin Houck, Kendal Locke, Allen Booth, and Richard Folgolman; (second row) Norman Davis, Violet Booth, Ruth Smith, Grace Thompson, Anna McLaughlin, John Pennington, Dorothy Currie, Mary Reside, Samuel Blessley, and unidentified; (third row) Ruth Reside, Clara Brent, Betty Pilkington, Alice Schmidt, Frances Roberts, Betty Fisher, Helen Shaw, Lois Dietman, and Shirley Roberts; (fourth row) Billy McKinley, Thomas Houck, Joseph Sipps, Joseph Lauginiger, John Stevenson, ? Graver (teacher), Ethel Gay, Naomie Reside, William Pilkington, and Edgar Loring.

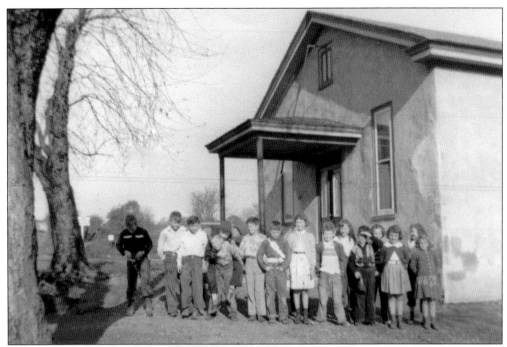

Here is a late-1940s photograph of students of School No. 1. Upon closer inspection, one can see that the boy on the far left is holding a toy gun. Considering the popularity of Western films and figures around this time, it is understandable that he would want to show his gun off at school. Needless to say, such a toy would not be allowed in school today.

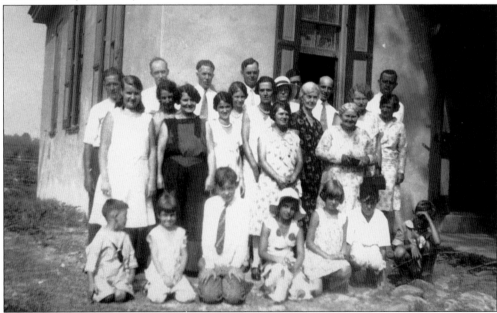

Taken in front of School No. 1, this photograph shows 26 members of the Cheyney family at a reunion held at the school. The clothing, the dress style, hairstyles, and the hat choices of the family members seem to indicate that this reunion occurred in the 1920s or 1930s. (Courtesy of Romaine Trump Jones.)

COMMENCEMENT EXERCISES

OF THE

BETHEL SCHOOLS

Tuesday Evening, June 11, 1912

ꙮ Program ꙮ

1. MARCH
2. INVOCATION - Rev. E. W. Gardener
3. MUSIC
4. MIXED CHORUS, "Welcome Joy and Feast"
5. ESSAY, "Amusements in the Early History
 of Bethel Township," Mifflin Bunker
6. MUSIC
7. SONG, "Just a Dream of you, Dear"
8. PIANO DUET, "The Fairy Queen"
 May E. Seidell, Emily T. Hinkson
9. LADIES' CHORUS, "Whisper"
10. ESSAY, "Historical Facts Concerning the
 Early History of Bethel Township," Charles Goodley
11. MUSIC
12. VOCAL SOLO, - - Madeleine Kidd
13. SONG, "Whistle It"
14. PRESENTATION OF DIPLOMAS
 Charles M. Cheyney
15. MUSIC
16. VOCAL SOLO, "Bird Song"--Scleithforth
 Mrs. J. M. Davidson
17. COMMENCEMENT ADDRESS, Dr. F. H. Green
18. MUSIC
19. BENEDICTION - Rev. J. S. Tomlinson
20. MUSIC

E. W. HILGERT, PRINTER, BOOTHWYN

Here is a detailed program for the commencement exercises of the Bethel Schools, which was possibly a combined event for students from each of the Bethel schools. The ceremony occurred on the evening of June 11, 1912. Both the presenter of diplomas, Charles M. Cheyney, and the commencement speaker, Dr. F.H. Green, were extremely significant in the educational aspects of Bethel. Interestingly enough, the evening was full of history due to the topics of the students' essays. The first essay, presented by Mifflin Bunker, was titled "Amusements in the Early History of Bethel Township." The second and final essay of the evening, presented by Charles Goodley, whose relative would later write a book on the history of Bethel, was titled "Historical Facts Concerning the Early History of Bethel Township."

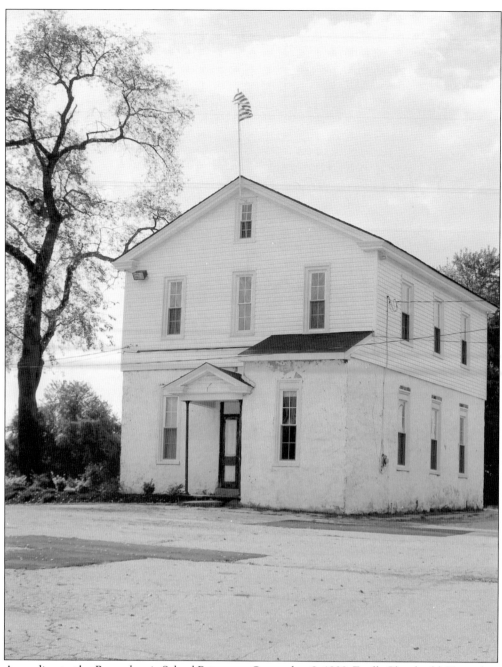

According to the *Pennsylvania School Report*, on September 9, 1839, Foulk Cloud sold 55 perches (about 0.34 acres) of land to the school board for $27.50 for School No. 2. An eight-sided school was built, known as Booth's Corner School. Although this structure burned in the 1840s, it was rebuilt using the walls of the original building. In the 1870s, the school was replaced with a one-story structure built by Nelson Green at a cost of $1,789. A frame second story was added in 1898. The second floor was designated School No. 4 for the township and was used as student population necessitated. The building was sold on September 2, 1953, to Brigg's Auction, the current owners, for $4,000.

District **Bethel** School **Booth's Corner** No. **Two** Grades **6 - 7 - 8**

ATTENDANCE RECORD FOR TERM SCHOLARSHIP RECORD FOR TERM

#	ROLL OF PUPILS	AGE AT BEGINNING OF TERM	TOTAL MINUTES TARDY	NO. TARDY MARKS RECORDED	EXCUSED	PARENTAL NEGLECT	ILLEGAL EMPLOYMENT	TRUANCY	TOTAL SESSIONS OF ABSENCE	AGGREGATE DAYS ATTENDED	AGGREGATE DAYS BELONGED	SESSIONS UNLAWFUL ABSENCE	GRADE IN SCHOOL	READING	WRITING	SPELLING	ARITHMETIC	GEOGRAPHY	LANGUAGE	HISTORY	HEALTH EDUCATION	MUSIC	DRAWING	CIVICS	GRADE IN SCHOOL 1923–1924
1	Bonanno Charles	14		14					14½	5	73		8	*moved*											8
2	Corbett Alexander	14		16					16½	3	180		8	*Co. Exam.*											8
3	Crawford Thomas	14		32	2½				34½	145	170½		6	85	75	70	70	80	75	75	70		80		7
4	Davis George A.	13		82	4				86	137	180	4	6	75	75	85	75	80	80	80	75				7
5	Davis George L.	13		68					68	146	180		6	80	85	80	85	85	80	80	85		75		7
6	Hoodley George	10		48					48	156	180		6	90	85	85	90	90	90	95	90		75		7
7	Petitdemange Alfred	11		38					38	144	180		6	90	80	90	90	85	85	80	90		85		7
8	Pilling Felton	12		39					38	158	180		6	85	75	90	85	85	70	90	85		70		7
9	Pilling Stanley	9		59					57	143	180		6	90	75	80	90	85	90	90	90		70		7
10	Simcox William	14		14					14	103	110		8	*Permitted to leave*											
11	Smith Gilbert	13		11					11	173	180		8	*Co. exam.*											9
12	Webster Kenneth	13	101	25	2				45	153	180	2	8	*Co. Exam.*											9
13	Whitby John	10		0					3	5	5		8	*Permitted to leave*											
14	Yerkes Wallace	12		8	2				10	125	180	2	8	*Co. exam*											9
15	Yerkes Warren	12		26	3				28	146	180	2	6	85	85	85	90	90	80	85	90		75		7
16	Zach Campbell	12		12					12	59	65		6	75	80	85	60	75	65	80	80		70		6
17																									
18																									
19																									
20																									
21																									
22																									
23																									
24																									
25																									
26																									
27																									
28																									

Use ink

Many interesting facts can be discerned upon close examination of this roll. There appear to be a good number of brothers and sisters and possibly cousins. The youngest student was nine years old and the oldest was 15. The entries for the children in the eighth grade include what became of them at the completion of said grade. They moved, took the county exam, or were permitted to leave assuming that their education was completed at this point.

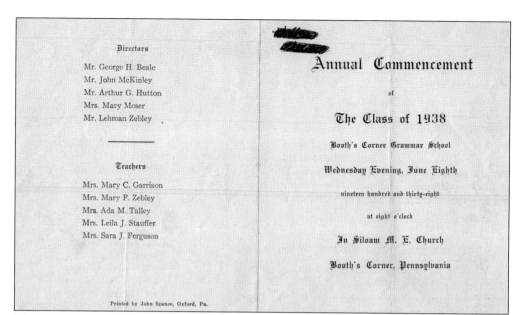

Annual Commencement

of

The Class of 1938

Booth's Corner Grammar School

Wednesday Evening, June Eighth

nineteen hundred and thirty-eight

at eight o'clock

In Siloam M. E. Church

Booth's Corner, Pennsylvania

Printed by John Spence, Oxford, Pa.

This is the outside of the commencement program for the class of 1938 of Booth's Corner Grammar School. The school offered classes through the eighth grade, so it can be assumed that the students listed were about to begin their ninth-grade year. As the front of the program explains, the exercises were held on the evening of June 8 in Siloam Methodist Episcopal Church, the same location as the earlier commencement program denotes. The back of the program lists the five school directors at that time and the five teachers at the school.

Programme

Processional
Invocation Rev. Mr. Bookar
Salute to The Flag The School
Salutatory Walter Davis
Lullaby and Good-Night School
What The Daisies Tell Anna Pilkington
Song of The Alps Elizabeth Deitman
My Creed Lucy Romauldi
Class History Dorothy Boudwin
By Mountain Springs Dorothy Mousely
Presentations { Robert Coughencur
 { Ada Mangold
Class Will Laura Cordingly
Class Doc Jerry Romauldi
Class Song Class
Solo Robert Hutton
Address Dr. Green
Valedictory Joseph Armstrong
Presentation of Diplomas and Seals
Benediction Rev. Bookar
Auld Lang Syne Recessional

Class Motto:
"Never Retreat."

Class Flower: **Class Colors:**
Rose Delphinium. Rose and Blue.

Class Roll:

Dorothy Mae Boudwin
Ada Janet Mangold
Lucy Marie Romauldi
Carrie Elizabeth Deitman
Dorothy Anne Mousely
Anna Beatrice Pilkington
Ciro Jerry Romauldi
Robert George Hutton
Walter Allen Davis
Robert Andrew Coughenour
Joseph Walter Armstrong
Harry Joseph McGroerty
Laura Elizabeth Cordingly

This is the inside section of the above commencement program from 1938. The commencement was only for one class of students that consisted of 13 students. The program also shows that the class had a class flower, the rose delphinium; class colors, rose and blue; and a class motto, "Never Retreat." The speaker is again Dr. Green, the same as in 1912. Some of the class members can be seen in later images in this chapter.

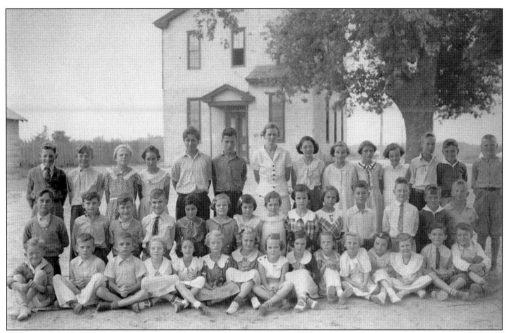

This class photograph was taken in front of School No. 2 (and School No. 4) in the mid-1930s. As shown, the framed second-floor addition was accessible only through an enclosed exterior stairwell. The second floor blends well with the first floor because it had been whitewashed during this period. The schoolchildren, from left to right, are (first row) Billy Pennington, ? Coggins, ? O'Boyle, Dot Zebley, Lila Mae Davis, Peggy Zebley, Helen Shaw, Clara Brent, Helen Ebright, Evelyn Wiggins, Martha Bonsall, Mary Ann Coggins, ? McNeal, John Pennington, and Joe Shulte; (second row) Tommy Houck, Paul Mangold, Ralph Marker, Maurice Poole, Annie Ritchie, Lois Dietman, Mary Whitby, ? McNeal, Vivian Pullin, Jean Lauginiger, Tom Booth, Frank Voshell, Wilbert "Bip" Davis, and Howard Husbands; (third row) Jack Wyatt, Irwin Houck, Evelyn Booth, Ethel Gay, Joe Degates, Henderson Pullin, Mary Zebley (teacher), Bea Davis, Louise Bonsall, Peggy Boyle, Frances Roberts, Joe Lauginiger, Wilfred "Utt" Davis, and Joe Dipps.

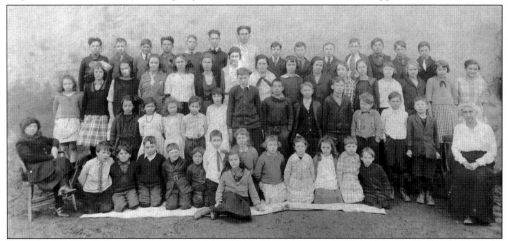

Here, 55 students pose for a class photograph at the Booth's Corner School. The two seated adults are most likely teachers. Based on the clothing and shoe styles that the children are wearing, this photograph was most likely taken in the early 20th century, possibly the 1910s.

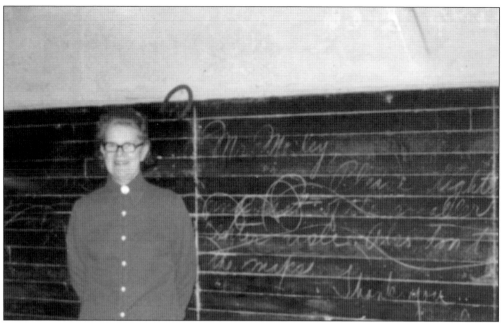

Before the start of the 1932 school year, Booth's Corner schoolteacher Jean (née Skokowski) Mast wrote a message on her blackboard to the secretary of the Bethel Township School Board, George Morley. Between the time she wrote the message and school starting again, the boards had been covered over with slate, unknowingly encasing the message to Morley. In 1975, as the second floor of the building was being renovated for use of the Bethel Township Historical Society, the slate was removed and the message from 1932 was rediscovered. Bethel Township Historical Society was able to contact the teacher, and here, she is standing by her words.

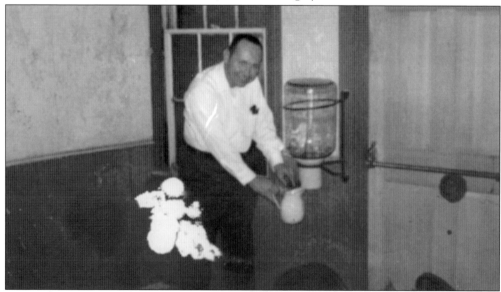

There was no running water in the school, and potable water was provided by Bethel Springs Water Company through coolers, as seen in this photograph of Reece Thomas. The lack of running water necessitated the use of privies, which are toilets located outside, and so, the school had one for girls and one for boys on opposite sides of the school from each other.

According to the *Pennsylvania School Report*, on May 22, 1860, Curtis Barlow sold 84 square perches (about 0.53 acres) to the Bethel Township School District for $129 to create School No. 3, also known as Chelsea School. A one-room schoolhouse was built on the property and used until 1952. It was sold in December 1952 for $1,500. It was then demolished to make way for high-tension wires. The former location of the building was on the west side of Foulk Road near the current McKinley Blacksmith Shop. This photograph was taken on September 8, 1948, four years before the school's demolition. The children featured in the picture are, from left to right, seven-year-old Katherine Barr, seven-year-old Raymond Davis, and nine-year-old James Davis.

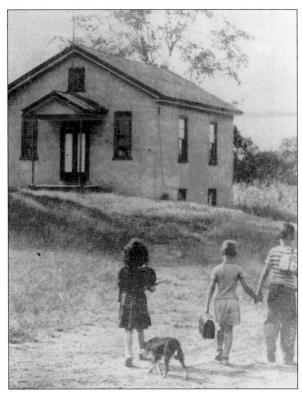

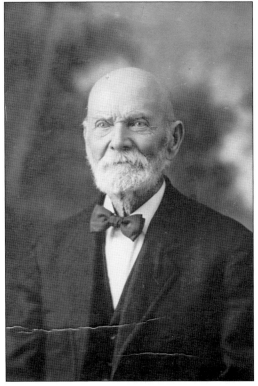

Charles M. Cheyney of Bethel served the schools of Bethel for over 50 years. Cheyney was a Civil War veteran and a farmer. As early as 1865, he was appointed a school director. This was a two-year appointment, and he served many terms until the first school board was elected in 1884. From that time until 1920, Cheyney served continuously as a member of the board. As a school inspector, Cheyney made annual visits. He took meticulous minutes for the school board, and to this end, citizens are indebted to him. (Courtesy of Romaine Trump Jones.)

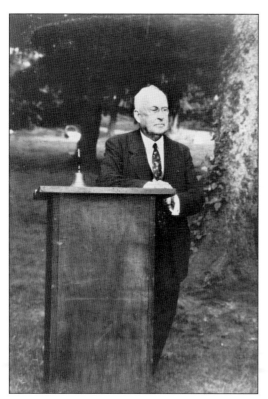

Another major mover in education was Francis Harvey Green, LLD. This native son grew up in Bethel and attended the local schools. He graduated from West Chester Normal School and then served on the faculty there, today's West Chester University, which houses a library named in his honor. He then became headmaster of the Pennington School in New Jersey for 25 years. A painting of him was done based on this photograph.

To show that Bethel Schools thought highly of Dr. Green, in 1949, he was named Pennsylvania ambassador. This award was presented during Pennsylvania Week and was for outstanding achievement in the best tradition of the commonwealth. (Courtesy of Jay Childress.)

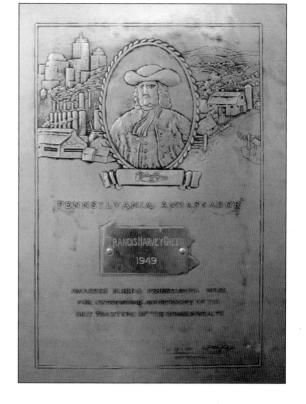

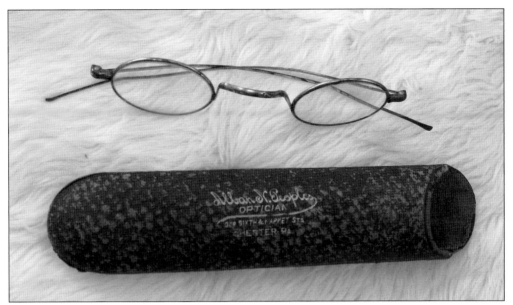

These are the glasses of Francis Harvey Green. A number of his personal effects were donated to the Francis Harvey Green School. These items were in display cases prominently located at the school. When the building was no longer being used as an elementary school, the cases were moved to the Garnet Valley Middle School. Due to the perseverance of members of the Bethel Township Preservation Society, these display cases have been moved to the Bethel Township Municipal Building, where they once again honor the memory of native son Francis Harvey Green. (Courtesy of Jay Childress.)

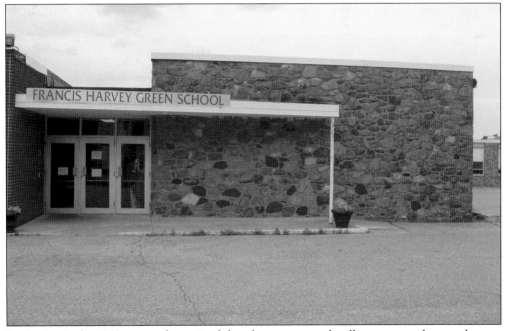

Beginning in the 1940s, it was determined that the one-room schoolhouse was no longer adequate to serve the growing needs of the community. The Francis Harvey Green School, a nine-room building, was constructed. (Courtesy of Jay Childress.)

THE HEADS OF FAMILIES AND FRIENDS WHO HAVE CONTRIBUTED TO
THE BETHEL TOWNSHIP SCHOOL BUILDING FUND

201 pledges — $15,020.00 (as of 5/9/50)

Chris Alscot	Dr. Francis Harvey Green	Bernard May	Samuel F. Valentine
Leslie Ashworth	Mrs. Bessie & Miss Kas	Wm. Meadowcroft	Warren R. VanDyke
Norman Ayers	Greenwood	Richard E. Merchant	Richard Wallace
J. Roy Baker	Charles W. Griffin	Louise J. Merrill	John A. Walls
William Barnshaw	Albert R. Grove	Alan Mewha	Joseph E. Walter
Raymond Baxter	Alfred S. Guy	Warren Michael	George J. Wanner
Mrs. George H. Beale	E. H. Habbersett, Jr.	James A. Miller, Jr.	Watson Warriner
Leonard Bergioll	Walter Hamblin	Hugh V. Morrison	John H. Weaver, Jr.
Samuel Blessley	Francis Hammond	Mary A. Moser	Lawrence H. Weller
Paul M. Bohn	Claude W. Hand	Ralph C. Neff	Ralph D. Weller
Virginia Booth	Clara Harkins	Albert O'Neil	Cornwell Willis
Orla F. Bowhall	Samuel E. Hannum	Joseph Osowski	S. J. Witowski
William Bradley	Walter Harvey	Walter Dawson and	Frank H. Woodworth
Howard Brong, Jr.	L. C. Hawkins	N. A. Patterson	Hayden Woodworth
Walter Campbell	John Heacock	George Palser	William H. Yates
Lawrence Carter	Watson Heavlow	John Pennington	George Zebley
A. B. Cheyney	A. Wayne Higgins	W. M. Pennington	Lehman F. Zebley
Norman Christopher	Robert D. Hild	J. E. Petherbridge	Jane Zebley
Atlee Clark	Mark Hill	Mary G. Petit deMange	James S. Zebley
A. G. Colucci	Oscar E. Holmes	George W. Peters	William L. Zebley, Jr
W. Ellis Comsar	J. Knos Hoopes	George W. Peters, Jr.	William L. Zebley, Sr
Robert Coughenour	Jay Huggins	Lawrence O. Peters	Reese Zebley
Frank C. Courtney	John A. Husbands	George H. Phillips	Emerick Zerbe
Leonard A. Courtney	J. M. Husbands	Frank E. Platt	
A. Warren Creamer	James Hutton	Clayton Poole	
George A. Davis	William Jennings	Robert C. Poore	
Wilbert Davis	Robert R. Jones, Jr.	Wesley J. Powers	ORGANIZATIONS
Harvey O. Davis	Robert R. Jones, Sr.	W. Ellis Preston	
Harold C. Davis	Frank A. Jones	Claude B. Ridington	Siloam Sunday School:
Felix Crovetto	Alvin O. Johnson	T. S. Rimal	Beacon Class
Harry J. Devitt	Carmen L. Johnson	John Robb	Comrade Class
Leonard Diamond	Howard Journey	William H. Robinson	Golden Links
Luisi D'Andreantteo	Harry L. Kailer, Jr.	Lillian Ryan	Young Men's Bible C
Earle N. Dickerson	Harry L. Kailer, Sr.	Harry B. Scholl	
A. C. Dodge	Paul Keen	Frank Schuser	W.S.C.S. - Siloam Chu
Charles Dooley	Bernard C. Kent	John J. Schott	P.T.A. of Bethel Town
James L. Draper	Albert J. Kerslake	Randolph Searle	Bethel Hose Co. #1
Joseph Duffy	John L. King	Luther Seltzer	Booth's Corner Minstr
F. S. Dupree	Robert H. King, Jr.	Alvah G. Smith	Ladies' Scout Auxilia
Edward G. Ebright	Ernest Knotts	Albert E. Smith	
Thomas E. Ellsworth	Wm. R. Lunkefeld	James Smith	
William Evans	Howard Larkin	Walter J. Smith	
Charles M. Faries	David Lewis	William Smith	
Charles Ferley	Earl E. Lofland	Arthur J. Steffenburg	
John F. Fannnaught	Bertram O. Long	Elmer R. Street	
George Feldman	Edward D. McLaughlin	Stephen L. Styer	
Clarence B. Felton	Albert J. McCann	Fred Suloff	
A. G. Ferguson	Robert McCauley	Harry A. Staub	
Harvey Fisher	John W. McCaffrey	Raymond W. Talley	
Andrew Ford	Victor McCoy	Wesley Talley	
W. Lehman Forwood	John McCoy	Wilson M. Talley	
William Foss	J. W. McKinley	Dexter M. Thompson	
George Fountain	Ralph A. McKinley	William Todd, Sr.	
Harry P. Garvine	John McKinley, Jr.	William J. Trump	
Donald Getchell	John McKinley, Sr.	Harry Tweddell	
Anthony F. Giamboy	Mattie McManany	William J. Twaddell	
Ulmer Gray	Peter Mangold	Charles Ulmer	

Prior to the nine-room school being built, financial resources were needed to underwrite this project. It was determined that the three older schools would need to be sold. A committee of citizens, led by Harry Kailer, William Robinson, Hayden Woodworth, Lehman Zebley, and others, volunteered its services and set out to raise money for the school using the public subscription method.

A contract to build the school was awarded to Walter Hibberd of Media, Pennsylvania. The contract estimate was $108,000, but the nine-room school was completed for $94,000. The school building committee decided the name of the school should be Francis Harvey Green. Ground breaking was October 15, 1950, with Dr. Green present for the ceremonies. (Courtesy of the Baxter family.)

Dedication of the new school took place on November 9, 1952. Regretfully, Francis Harvey Green died before the dedication. Lehman Zebley presented a portrait of Dr. Green to be placed in the entranceway of the school.

This picture of the fourth and fifth grades on April 28, 1953 shows what a typical classroom in the new school looked like, with windows facing out to the playground and fields east of the building. Students are, from left to right by row and front to back, (first row) Tom Maas, Earl Chambers, Eben Dodge, Julie Almont, and Carl Sutton; (second row) Mary Hood, Harriet Armstrong, Richard Bohn, Shirley Neide Wynne, Florence Cannon, unidentified boy, and unidentified girl; (third row) Tom Hannum, unidentified boy, Cleaves Dodge, Ruth White, Linda Lock, and Douglas Baxter; (fourth row) Barry McKinley, Denis Pendelakus, Shirley Guy, Ed Ebright, and Judson Griggs; (fifth row) Ralph McKinley, Stewart Lewis, Joan Summers, Tom Gillespie, unidentified boy, Janet Gray, and Nancy Fox (immediately left of J. Gray); (sixth row) George Warner, Guy Orlando, unidentified boy, and Douglas Hevalow; (seventh row) Judy Suloff, Gail Woodworth, Gwen Woodworth, unidentified boy, and Irvin Maas; (standing) are Lester Gray and teacher Ardee Oliver. (Courtesy of Douglas Baxter.)

THE FRANCIS HARVEY GREEN SCHOOL

DEDICATION PROGRAM — SUNDAY, NOVEMBER 9, 1952

Prelude Tall Cedars Band of Penn Forest, Chester, Pa.
Charles Buckley, Director

Invocation Rev. Richard C. Chapin

Flag Raising Boothwyn Post No 951, American Legion

Welcome Bethel Township School Board,
Geo. W. Feldmann, President

"Couplets of Appreciation" Mrs. Estelle G. Seal,
Principal

Functions of the PTA John L. King, President

Plaque Presentation William H. Robinson,
Chairman, School Building Fund Committee

Superintendent of Delaware County Schools
Dr. Carl G. Leech

Superintendent of Education, Media Dr. Fred Tanger

Presentation of Classroom Bibles Rev. Richard C. Chapin

Interlude ... Tall Cedars Band

Address — "Building for Tomorrow"
Rev. Geo. W. Goodley, Hillcrest Methodist Church

Presentation of Dr. Green's Portrait Lehman F. Zebley

"Education and Good Citizenship" W. W. Weston
Sun Oil Co.

School Song Pupils of The Francis Harvey Green School

Benediction Rev. Richard C. Chapin

School Inspection Faculty and PTA Assisting

EVERYBODY WELCOME!

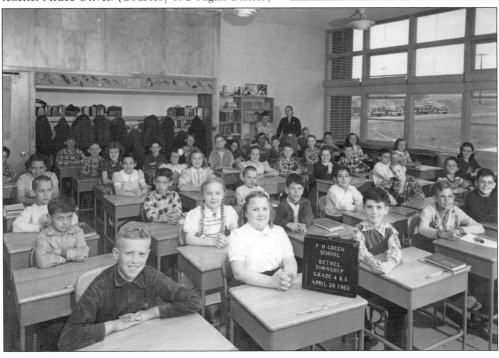

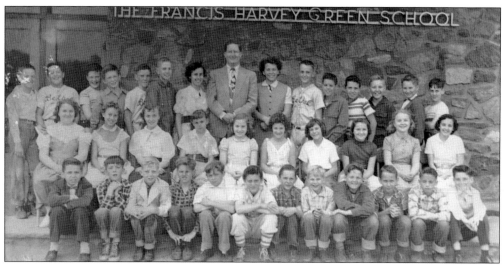

Pictured are the seventh and eighth grades from 1955 with their teacher James Singley. Students are, from left to right, (first row) Richard Wallace, Leonard Ulmer, two unidentified, Earl Chambers, Lloyd Byers, Cleaves Dodge, John Robb, Jim Crovetto, Eben Dodge, Richard Bohn, and Tom Hannum; (second row) Mary Hood Ruch, Barbara Shellenberg, Rita Weber Wilson, Diane Higgins, Robin Lee, Sharon Jackson, Beverly Holmes, Joyce Thomas, Harriet Armstrong, and Shirley Neide Wynne; (third row) unidentified boy, Carl Sutton, Bill Robinson, Eugene Foss, Douglas Baxter, Judson Griggs, Carol Meli Gumrot, Singley, Julie Almont, Francis Downey, Don McDaniel, Joe Pagano, unidentified boy, Len Bergdoll, and Ted Lewis. (Courtesy of Denis Pandelakis and Douglas Baxter.)

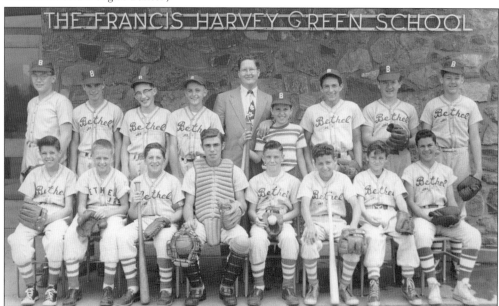

In this Francis Harvey Green School baseball team picture are, from left to right, (first row) Don McDaniel, Doug Hevalow, Carl Sutton, Wally Davis, Doug Baxter, Guy Orlando, Lloyd Byers, and Ralph McKinley; (second row) Bill Northington, Ralph Davis, Jerry Hammond, Francis Downey, teacher and coach James Singley, Joe Pagano, Frank Davis, ? Armstrong, and Jim Miller. (Courtesy of Douglas Baxter.)

May Fair was an early tradition when the Francis Harvey Green School was new. The purpose was to raise funds for the school. The Parent-Teacher Association would set up booths and sell things to the children, such as lemon suckers. The children would start their event by bringing their chairs out from classrooms and lining them around the perimeter of the blacktop. Each classroom would parade around the perimeter with parents looking on in the background. (Courtesy of Douglas Baxter.)

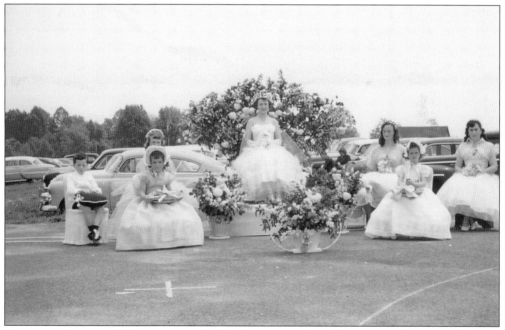

Every year, there would be a court and a May Fair queen. Janet Hoopes was the queen this year, and she was attended by, from left to right, (first row) Phyllis Baxter and an unidentified girl; (second row) an unidentified boy, Margaret Cheyney, Carolyn Ashworth, and an unidentified girl. (Courtesy of Phyllis Baxter Woolfe.)

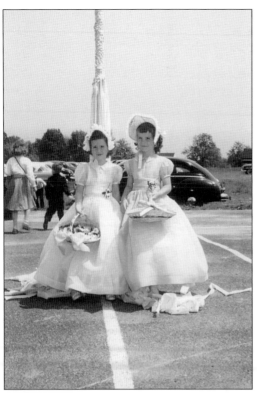

An unidentified girl (left) and Phyllis Baxter are standing in front of the maypole. The fourth-grade class each year would do the maypole dance. (Courtesy of Phyllis Baxter Woolfe.)

Douglas Baxter is dressed to the hilt. The class was studying the medieval period. By wearing costumes such as Baxter's, students were able to show what they had learned during the school year. (Courtesy of Douglas Baxter.)

In this picture of the May Fair, it appears as though the class studying medieval history has just knighted a student. (Courtesy of Douglas Baxter.)

You are cordially invited to attend the

Graduation Exercises of the Eighth Grade

of the

Francis Harvey Green School

Cloud Memorial Siloam Methodist Church

Booth's Corner, Pennsylvania

Tuesday Evening June Fourth

Nineteen hundred and fifty=seven

at eight o'clock

Even as late as 1957, eighth-grade graduation was still being held in Cloud Memorial Hall at Siloam Methodist Church since the gymnasium had not yet been built. (Courtesy of Douglas Baxter.)

PARENTS - TAXPAYERS - VOTERS

ARE YOU AGAINST THE COMPLUSORY JOINTURE OF SCHOOLS? THEN LET'S SHOW THE PEOPLE IN OFFICE JUST HOW WE FEEL ABOUT THIS MATTER.

A COMMITTEE WILL BE FORMED OF EVERYDAY WORKING PEOPLE WHO BELIEVE IN THE RIGHT OF THE PEOPLE TO BE HEARD.

AS COVERED BY THE DAILEY TIMES THE SCHOOL BOARD HAS AGREED TO APPEAL ACT #299 (THE FORCED MERGER OF CONCORD, BETHEL, CHESTER HEIGHTS, ASTON, PARKSIDE AND BROOKHAVEN) LET'S BACK UP OUR SCHOOL BOARD BY GIVING PUBLIC SUPPORT SO STRONG THAT OUR REPRESENT-ATIVES WILL STAND UP AND TAKE NOTICE. PASS SENATE BILL #202 AND HOUSE BILL #144 WHICH IS BOTTLED UP IN THE COMMITTEE ON EDUCATION BY COMMITTEE CHAIRMAN THOMAS LAMB OF PITTSBURGH.

ASK YOURSELF - DO I WANT MY CHILDREN TO TRAVEL TO ANOTHER SCHOOL FARTHER AWAY OR GO TO GARNET VALLEY? REMEMBER HOW YOU OR YOUR NEIGHBORS WERE GLAD WHEN THE CHILDREN DIDN'T HAVE TO WASTE THEIR TIME WAITING IN MEDIA. THE TWO BUS "EXCURSIONS" PER DAY WOULD BE TIME CONSUMING FOR THE CHILDREN AND HORRIFING FOR THE MOTHERS WHO HAVE TO THINK OF THEIR CHILDREN BEING EXPOSED TO DANGEROUS TRAFFIC, WEATHER CONDITIONS AND IDLE HOURS.

WE ALL NEED EACH OTHERS SUPPORT. WE CAN NOT COUNT ON JUST A FEW, WE ARE RELYING ON EVERYONE OF YOU. THOSE NOT IN FAVOR OF THIS JOINTURE COME OUT AND BE COUNTED.

OUR SCHOOL DISTRICT NOW CONSIST OF 21.39 SQ. MILES CONSISTING OF CONCORD, BETHEL AND CHESTER HEIGHTS. WE TAXPAYERS AND PARENTS KNOW THIS IS A LARGE ENOUGH JOINTURE SO LET'S WORK TO KEEP IT THAT WAY.

YOU WILL BE CONTACTED CONCERNING MEETING.

Public Act No. 299 of 1963 was written to institute school mergers. The State of Pennsylvania saw a need to streamline the number of school districts within the state. It appears as though Delaware was the only county to fight this act. The initial number of districts was 2,277, which was reduced to 669. What Garnet Valley had in its favor was that the district already was comprised of 21 square miles and was undeveloped at this time.

Mr. and Mrs. Taxpayer:

What Do We Want?

Public Act #299 must be repealed. Public Act #299 has deprived the taxpayer of the right to decide how or by whom he shall be taxed and represented. The people of Delaware and New Jersey have this right. Why don't we?

How Can We Do This?

We the people must unite

Let our elected officers know of our disapproval and FORCE repeal of Public Act #299

This can be done by united PUBLIC ACTION!

How to Get Public Action?

Form a committee of approx. 25 captains, each representing a section of Garnet Valley.

Each captain should have 10 committee members.

Each committee member should organize 10 citizens.

What Public Action?

1. Public movie on the situation.

2. Get each taxpayer to 'phone his elected officials.

3. Get each taxpayer to/write his elected officials.

4. Hold public gathering with newspaper, radio, and T.V. Coverage.

5. Petitions to every interested official.

6. Hold public demonstration if necessary.

This is an appeal to repeal Public Act No. 299. There was a grassroots effort to organize parents to fight this. Pictured on the previous page and this page are letters of protest that were sent to parents and taxpayers in Bethel Township in 1965. These letters discuss Public Act No. 299, the compulsory jointure of schools in Bethel, Concord, Chester Heights, Aston, Parkside, and Brookhaven. The letters called for taxpayers and parents to work together to fight this merger. With this extensive campaign, the organizers were successful, and the merger of the schools never occurred.

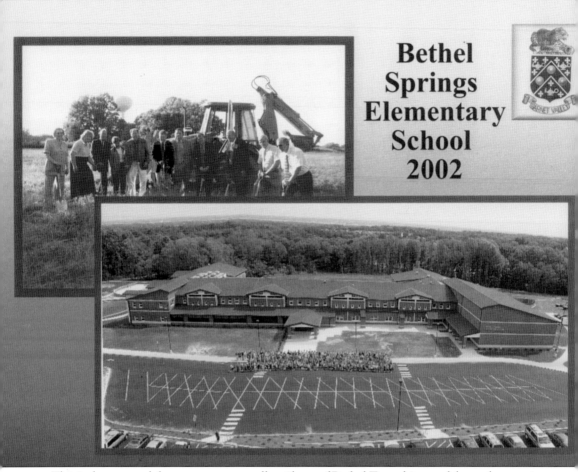

Bethel Springs Elementary School 2002

This is the postcard that was sent out to all residents of Bethel Township to celebrate the opening of Bethel Springs Elementary School in 2002.

Six

ENTERTAINMENT

There is always something to do on the weekends in Bethel Township. Here, people cannot only watch a show but can also get a bargain at the same time. There are places for relaxation, leisurely shopping, musical concerts, picnics, and other social gatherings. The townspeople of Bethel have always had quite a few options for entertainment. In the 1950s, the television show *Candid Camera* used a spot on Ebright Road to film a segment about Delaware being closed because it had reached capacity and was full. Sadly, no pictures were gathered depicting this event. The images in this chapter document the people, places, and pleasures of Bethel Township.

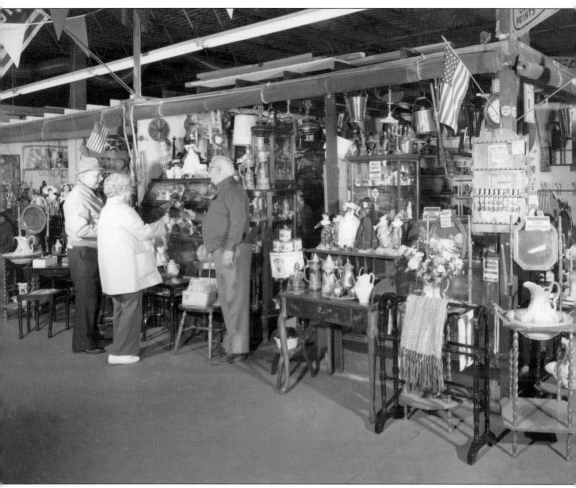

Pictured is a stand at the Booth's Corner Farmers Market in the 1970s. This vendor is selling wares that could include antiques and secondhand items as well as some new items. Customers were free to browse.

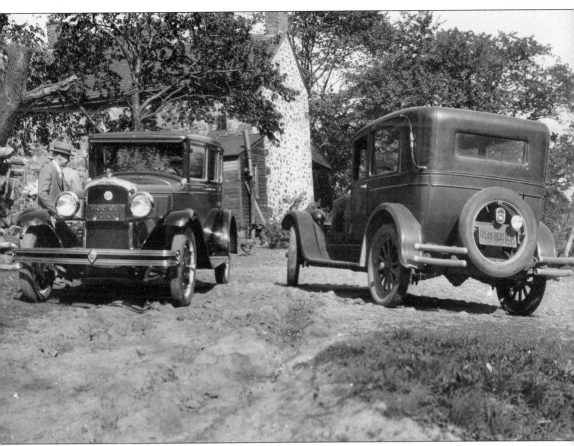

Here, Harry Gravelle is pictured outside of the Sarum Farm barn next to his car. Harry would go on to become an engineer on the Hoover Dam. (Courtesy of Romaine Trump Jones.)

Beverage List

Cocktails Served after 2 P. M.

The finest of ingredients are used in the making of all drinks.

Dinner Served after 7 P. M.

Our French Cuisine will please you and our music and entertainment is always the best.

CHELSEA COUNTRY CLUB

Faulk Road, Chelsea, Penna.

Open Week Days from 2 P. M. to 2 A. M.

Open Saturday at noon

'Phone Chester Heights 81

The Chelsea County Club was a source of entertainment at the turn of the 20th century. It was located on the hill near the mansion on Foulk Road. A former resident recalled horsemen and hounds chasing a fox on Laughead Lane in the 1910s, which could have been organized by the Chelsea Country Club. Very few items remain that document the existence of this country club; one piece of proof is this beverage list from the club. (Courtesy of Delaware County History. com—Keith Lockhart.)

CLARET—IMPORTED

	Bot.	½ Bot.
Medoc	3.00	1.50
St. Julien	3.00	1.50
Pontet Canet	4.00	2.50
Chablis	4.00	2.50
Chat. Lascombes Marquax	5.00	
Chat. Lafitte Careasset	4.00	

COBBLERS

Claret	.50
Syrup, Fruit	
Port Wine	.50
Syrup, Fruit	
Rhine Wine	.50
Syrup, Fruit	
Sherry	.50
Syrup, Fruit	
Whiskey	.50
Bourbon, Curacao, Lemon, Fruit	

WINES

CHAMPAGNE—IMPORTED

	Bot.	½ Bot.
Heidsick	7.50	4.00
G. H. Mumm's Ex. Dry	8.00	4.50
Moet-et-Chandon White Seal	10.00	5.00
Clicquot Yellow Label	9.00	5.00
Irroy Extra Dry Ruinart 1923	8.00	4.00

ITALIAN—IMPORTED

Chianti-Antinori	3.00
Marsala-Florio S. O. M.	3.00
Orvieto-Antinori	3.00

MADEIRA—IMPORTED

White Label—Cossart Gor.	4.00
Brown Label—Cossart Gor.	4.50
San Pedro—Powers & Drury	4.50

TONIC—IMPORTED

Dubonnet	3.00

SAUTERNES—IMPORTED

	Bot.	½ Bot.
Graves	3.00	1.50
Chateau Yquem	10.00	5.00
Barsac	3.50	1.75
Monopole Blanc Nonpariel	3.00	
Superior	3.50	1.75

RHINE—IMPORTED

	Bot.	½ Bot.
Laubenheimer	3.00	1.50
Hockheimer	4.50	2.25
Ruedesheimer Beig	6.00	3.00
Leibfraunilch Auslese	6.00	

BURGUNDY—IMPORTED

	Bot.	½ Bot.
Commard	4.00	2.50
Chablis (White)	4.00	2.50
Nuits St. George	4.00	
Macon	4.00	2.00

PORT—IMPORTED

Old Tawney	4.00
Diamond Jubilee	4.00
Royal Palace	6.00
Ruby 5 Star	3.00

SHERRY—IMPORTED

Amontillado	4.00
White Label	3.50
Santa Maria Dry	4.00
Manzanilla	4.00

SPARKLING MOSELLE IMPORTED

	Bot.	½ Bot.
Leidens	9.00	4.50

MOSELLE—Imported

	Bot.	½ Bot.
Zeltinger	3.00	1.50
B ncastler	4.00	2.00
Zeitingen Berg	3.00	
Burgermeister	4.00	

SPARKLING BURGUNDY IMPORTED

	Bot.	½ Bot.
Chauvenets Red Cap	7.00	3.50
Cruse Fils	7.00	3.50
Calvet Cie	7.00	3.50

Note the many unusual drinks that are not common today. Rum punch is familiar because it is from *It's a Wonderful Life*, but the movie does not mention cobblers. This property burned to the ground in the 1930s around the same time when Bethel Township voted to become a dry community in 1935. Local folklore implies a connection between the sudden disappearance of all evidence of the Chelsea Country Club due to fire and the rise of the prohibition movement in American culture. The only remains of the country club today are two freestanding chimneys. (Courtesy of Delaware County History.com—Keith Lockhart.)

What was needed was good clean entertainment, and that was found in Radio Park with Cousin Lee and His Boys. Here is James McLaughlin's membership certificate. He became a member on Valentine's Day 1941.

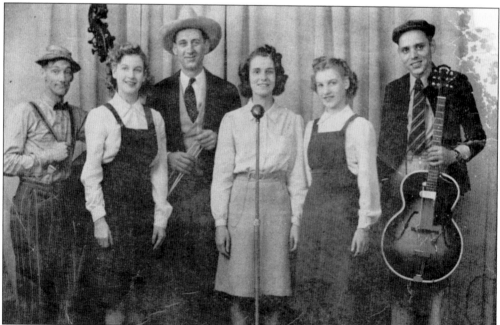

Cousin Lee had a venue at Radio Park, which was located near the intersection of Ebright Road and Naamans Creek Road. In amongst the trees at Pennington Woods, there was a grandstand as well as a midway. Cousin Lee would book different groups to perform each weekend, and some performers went on to be quite famous.

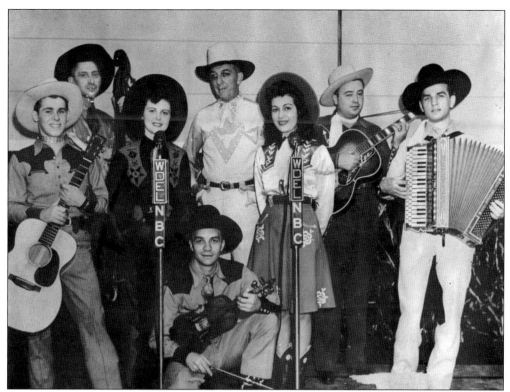

Cousin Lee was known for his white cowboy hat and white attire. He would have local groups and national groups come and perform. A scrapbook from the time showed many famous people. Tex Ritter and Roy Rodgers performed at Radio Park. (Courtesy of Lois Campbell Pennington.)

But the local boy who made good was the famous Bill Haley. One of his first appearances was in 1938 when he performed at Bethel Junior baseball team's entertainment event. The program has him listed under guitar and songs. He was almost 13 years old at the time of this performance. (Courtesy of Josephine Schott McDaniel.)

BETHEL JUNIOR BASEBALL TEAM'S
ENTERTAINMENT

0 Thursday, April 7th 1938

PROGRAMME

PART I

Musical Selections................The "Hill Billies"

Charlie McCarthy Act................Wilbert Davis

Violin Solos................Robert Long

Harmonica Solos................Harry Founds

Boxing Act................Wm. Ronda & Wilfred Davis

Guitar and Songs................William Haley

Mystic Mind Reader................Norman Davis

PART II

SIX WIVES ON A RAMPAGE.......Three Act Comedy-Drama

Act I.....Combination living room and dining
room of a summer cabin in the Cats-
kills. Late afternoon of a stormy
June day.
Act II....Same as in Act I. Early the follow-
ing morning.
Act III...Same as in the previous acts. Three
days later, in the morning, before daylight.

Buzz...........Jennie Husbands
Harrie.........Lorraine Davis
Sassy...........Alice Talley
Roma...........Willena Hutton
Bo.............Isabel Booth
Dee............Anna Davis
Pam............Pricilla Davis
Jim............Harry Kailer
Jack...........Lawrence Weller
Sheriff Bungle...Herb Philson
Bill...........Edward Cheyney
"Let Me Call You Sweetheart".....By the Cast

PART III

"The Ghost Walks at Midnight" --- A sketch by:
Mr. Rojer Culver, Mr. E.B.Burnley, Sr., and
Mr. Harry Longbottom.

GOODNIGHT !!!! -----"AULD LANG SYNE"-----THE ENTIRE CAST

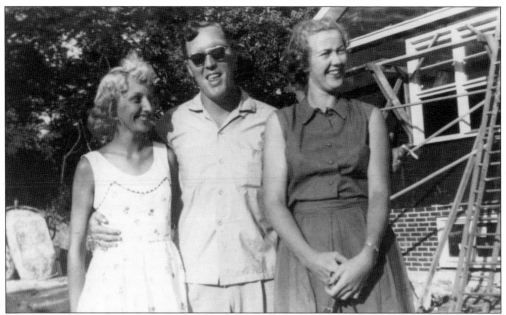

This photograph, taken in 1954, includes, from left to right, Cuppy, Bill's wife; Bill Haley; and Bill's sister Peggy. Melody Manor, which is shown under construction, is in the background. Melody Manor was the home that Bill built near the intersection of Foulk and Bethel Roads. (Courtesy of Bill Haley Jr., Haley family collection.)

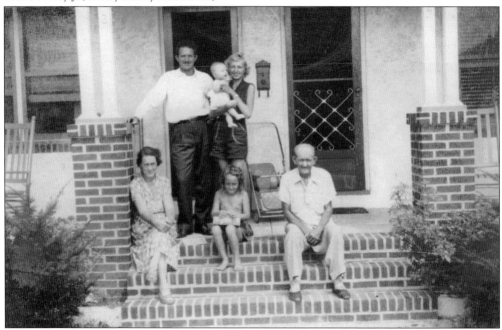

This is the original house on the property where Bill Haley lived as a boy. Seated on the steps are Bill's mother, Maude Green Haley, and his father, William "Will" Albert Haley. Seated between them is Bill's first daughter, Sharyn. Standing on the porch are Harry Broomall, who worked for Bill Haley, and Bill's wife, Cuppy, holding his daughter Joanie. This photograph was taken in the summer of 1953. (Courtesy of Bill Haley Jr., Haley family collection.)

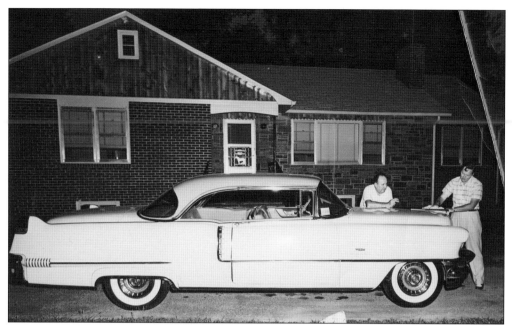

Here, Bill Haley (right) is washing one of his Cadillacs in front of Melody Manor. Leaning on the car is his manager, Lord Jim Ferguson, who was also a resident of Booth's Corner. He and Bill Haley owned an art gallery located next to the Booth's Corner Farmers Market in 1956. (Courtesy of Bill Haley Jr., Haley family collection.)

Lord Jim (left) and Bill Haley are seen standing under one of the apple trees in the front yard of Melody Manor. Bill's father, Will Haley, planted these trees shortly after he bought the seven-acre property in the late 1930s. (Courtesy of Bill Haley Jr., Haley family collection.)

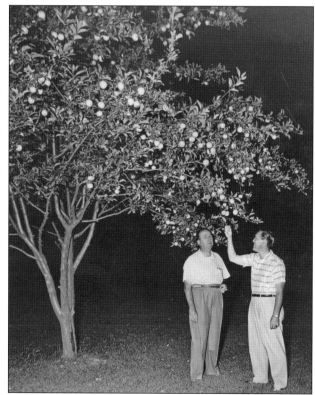

Here are the front steps of the completed Melody Manor. The name Haley is in the grillwork of the front door. (Courtesy of Bill Haley Jr., Haley family collection.)

Bill Haley is pitching horseshoes at a backyard party at Melody Manor in 1956. Behind him is Billy Williamson, the lap steel guitar player in The Comets. (Courtesy of Bill Haley Jr., Haley family collection.)

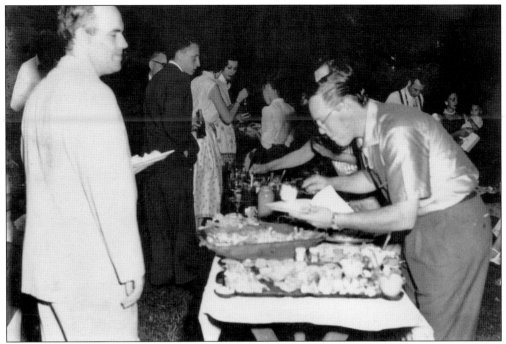

This photograph depicts the same backyard party at Melody Manor in 1956 as the previous image. (Courtesy of Bill Haley Jr., Haley family collection.)

This photograph of Bill Haley standing in the driveway at Melody Manor was taken in March 1957. (Courtesy of Bill Haley Jr., Haley family collection.)

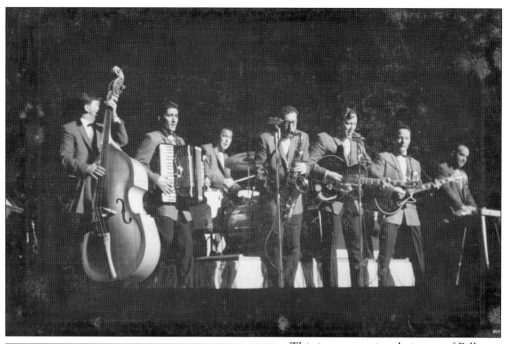

This is a promotional picture of Bill Haley and his band that he would send to his fans. This picture could be from his European tour as it was sent by Haley while he was on tour in Germany. (Courtesy of Jay Childress.)

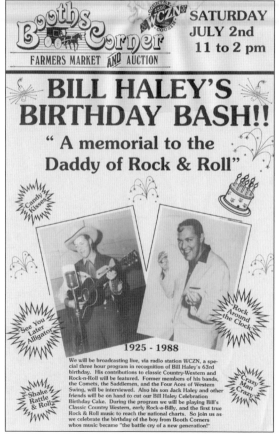

Even after his death, Bill Haley was still honored by his hometown. In 1988, a memorial birthday bash was thrown. This was held at Booth's Corner Farmers Market and Auction in conjunction with radio station 1590 WCZN, known as "Country Cousin on AM Stereo." This was after he was inducted into the Rock and Roll Hall of Fame. In attendance at the birthday bash were Jack Haley and former members of his bands. (Courtesy of Jay Childress and Booth's Corner Farmers Market.)

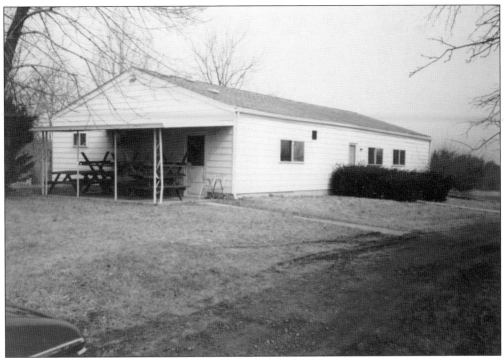

This picnic park, also known as St. Mary's Church grounds, was located on the land across from the Goodley Farm on Goodley Road. At one time, it was used as a day camp.

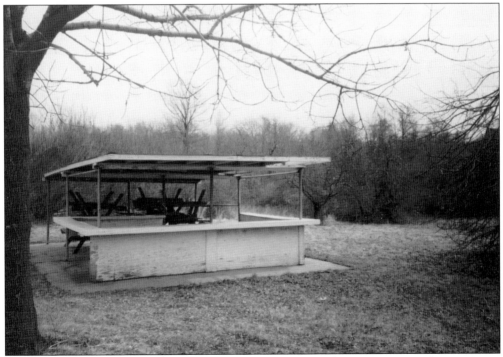

For a time in the 1970s, the annual corn boil was moved to St. Mary's Church grounds. There was no church on the grounds but just a few buildings where outdoor events could be held.

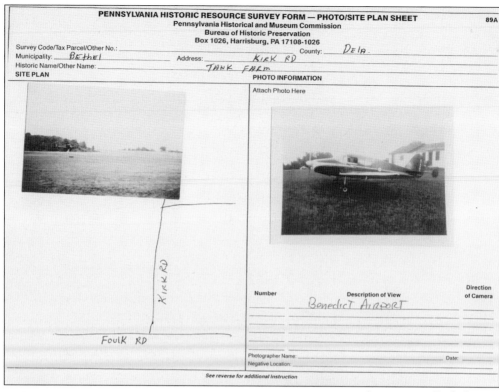

PENNSYLVANIA HISTORIC RESOURCE SURVEY FORM — PHOTO/SITE PLAN SHEET

89A

Pennsylvania Historical and Museum Commission
Bureau of Historic Preservation
Box 1026, Harrisburg, PA 17108-1026

Survey Code/Tax Parcel/Other No.: _____ County: _Dela._
Municipality: _Bethel_ Address: _Kirk Rd_
Historic Name/Other Name: _Tank Farm_

SITE PLAN | PHOTO INFORMATION

Kirk Rd

Foulk Rd

Attach Photo Here

Number	Description of View	Direction of Camera
	Benedict Airport	

Photographer Name: _____ Date: _____
Negative Location: _____

See reverse for additional instruction

Here is your list of SKYTOURS' AIR RESORTS and their operators, current of Aug. 1948. The numbers show their relative locations on the above map.

1- AIR HOLIDAY INN
Groton Trumbull Airport
Groton, Conn.
Frank E. Nagle

2- BLANEY PARK
Blaney Park, Mich.
Edward Drier

3- BRADLEY SKYTEL
Bradley Field
Box 829, Boise, Idaho
John D. Bradley

4- CURRIER'S VILLAGE
Lakeside, Oregon
E. M. Madsen

5- FLYING L RANCH
Bandera, Texas
Col. Jack Lapham

6- GRAY ROCKS INN
St. Jovite Station
Quebec, Canada
Tom Wheeler

7- HONEYMOON ISLE
Dunedin, Fla.
C. M. Washburn

8- KING'S GATEWAY HOTEL
Land O' Lakes, Wis.
John J. Garber

9- OTIS LODGE
Sugar Lake
Grand Rapids, Minn.
Arthur R. Otis

10- "RED'S" WALLOWA RANCH
219 Morgan Building
Portland 5, Ore.
J. G. Sanderson

11- ROCCO'S VILLA SUNSET
Lake Susquehanna
Blairstown, N.J.
Rocco B. Bunino

12 SKY LODGE
Jackman, Maine
Jerome B. Bates

At one time, Bethel Township was home to the Benedict Airport. It was located where the tank field is today on Kirk Road. John T. Benedict started this airport in 1938. This was an airport for small airplanes, specifically for Piper-type planes.

This is a listing of destinations out of Bethel's airport. The airport was a part of Skytour's Air Resorts. The listing below the image features other inns, ranches, and lodges which the passengers could visit as a part of Skytour.

This picture is of a plane that was flown out of Benedict Airport in the early part of the 20th century.

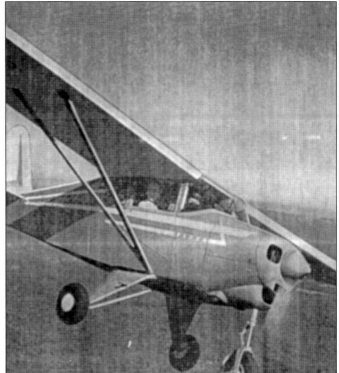

Seen here is Everett J. Wood, the co-operator of Delco Airport, also known as Benedict Airport. He was the father of Pete Wood. Paired with the picture is a poem called "He's a Pilot, Too."

He's A Pilot, Too

Someday we will know, where the pilots go
When their work on earth is through.
Where the air is clean, and the engines gleam.
And the skies are always blue.
They have flown alone, with the engine's moan,
As they sweat the great beyond.
And they take delight, at the awesome sight
of the world spread far and yon.
Yet not alone, for above the moan, when the earth is
out of sight,
As they make their stand. He takes their hand,
and guides them through the night,

How near to God are these men of sod,
Who step near death's last door?
Oh, these men are real, not made of steel,
But He knows who goes before.
And how they live, and love and are beloved,
But their love is most for air.
And with death about, they will still fly out,
And leave there troubles there.
He knows these things, of men with wings,
And He knows they are surely true.
And He will give a hand, to such a man
'Cause He's a pilot too.

Minstrel shows, which are now considered to be offensive as performers appear in blackface, were once very popular in Bethel Township. They were performed from 1932 until as late as 1969. Their purpose was to raise funds for the American Legion or the firehouse. This photograph is a formal picture of those who participated in the Booth's Corner Minstrel Show in 1941 at the firehouse.

In this image taken at a minstrel show, actors are performing a bathing scene. In many of the vignettes performed, men would dress as women.

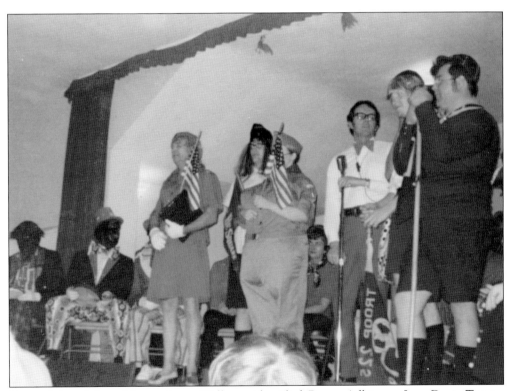

Pictured, from left to right, are Larry Weller, unidentified, Bunny Adkinson, Jerry Davis, Tommy Adkinson, and Bob Griffin. Note that Bunny was not normally the shape she is in this image.

BENEFIT BASE BALL GAMES

Bethel Cubs vs. Elam Cubs, 1:30 P. M.

Bethel A. A. vs. Arden, 3:15 P. M.

AT BETHEL FIELD

Saturday, July 29, 1939

TICKETS 15 CENTS

HUMMEL PRINT. BOOTHWYN, PA.

Baseball was a very early form of entertainment in the township; this flyer is from 1939. For the price of 15¢, one could be entertained and the monies earn would go toward a worthy cause. Here, the Bethel Cubs were pitted against their neighbors to the north, the Elam Cubs, and the Bethel A.A. team was scheduled to play its neighbor to the south from Arden, Delaware.

The local Veterans of Foreign Wars (VFW) Post No. 6835, now known as VFW Bethel Post, is enjoying the outdoors in the late 1980s. Not only do the members of the post gather for fellowship but they also serve as the honor guard for the Memorial Day parade. They remind people of the sacrifices that have been made, and are continually being made, for a free country.

Seven

HISTORY COMES ALIVE

The history in Bethel Township lives on in the memories of its residents and is celebrated through festivals and annual events. Some members of the township have banned together to preserve these memories, thus creating Bethel Township Preservation Society. The chapter focuses on those who recorded the history of Bethel Township—from the written works of the early township fathers to the Bethel Township Historical Society, which was formed to celebrate the bicentennial—and on the restoration of the Southery Log House, which physically preserves Bethel history.

APPLICATION FOR MEMBERSHIP IN
BETHEL TOWNSHIP HISTORICAL SOCIETY

Type: Active ☐ Junior ☐ Associate ☐

Name ...

Address ..

Phone Occupation ..

Information about yourself: ...

...

What Historical Real Estate do you own? ...

...

What Crafts or Hobbies do you have that may be of use to the Society?

...

Do you have Township-related Artifacts that could be loaned or donated to the Society?

...

...

For quite some time, history has been important to the residents of Bethel Township. In 1974, the Bethel Township Historical Society (BTHS) was formed. One of its first orders of business was to get ready for the country's bicentennial.

Early on, the BTHS recognized the importance of saving and preserving history by way of archiving items of historical importance. Among the first items the group collected were water bottles from Bethel Springs. In these boxes are a number of different types of bottles from the company, such as five-gallon bottles, embossed bottles, seven-ounce bottles, and those with paper labels.

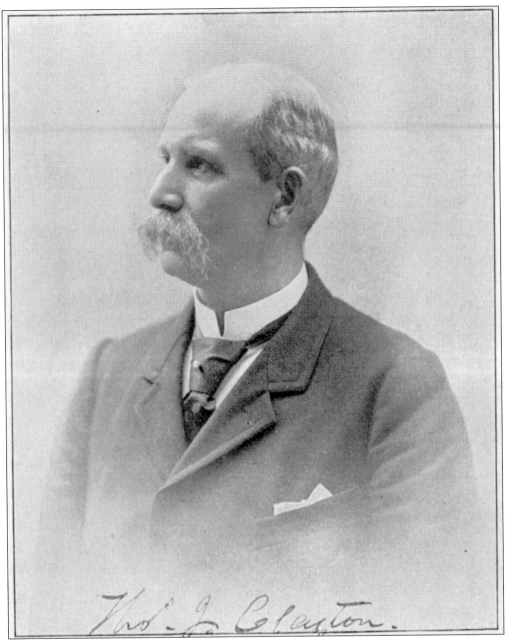

Judge Thomas Jefferson Clayton was one of those who kept history alive by writing his memoir, titled *Ramblings and Reflections Here and Abroad*. Hopefully, Bethel Township Preservation Society will continue to keep history though its *Journal*. The *Journal* not only tells stories from the past but also documents current events that affect the area's history.

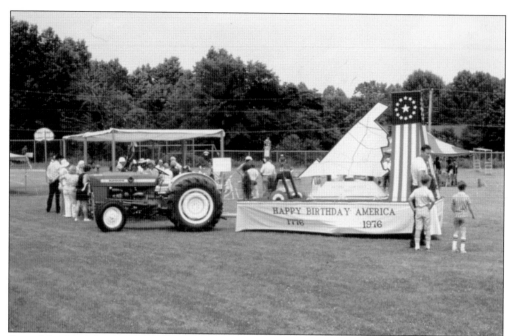

One of the first activities the BTHS participated in was the parade commemorating the bicentennial of the United States. This particular float in the parade is an outline of the township mounted on a stand that reads "Bethel Township 1683," and the trailer has a sign that reads, "Happy Birthday America 1776–1976." John Adkinson and John Myers worked on this particular float.

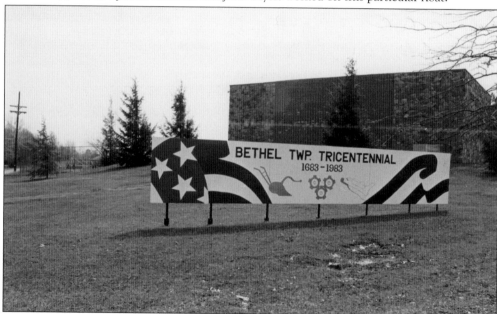

To commemorate the 300th anniversary of the township in 1983, this banner was erected outside of Francis Harvey Green School on the corner of Foulk and Bethel Roads. The emblems used to represent the community were a plow to honor the farming heritage past, gears to represent the industrial present, and a space shuttle to honor the future. It is interesting to note that the space shuttle has become obsolete in just 30 years.

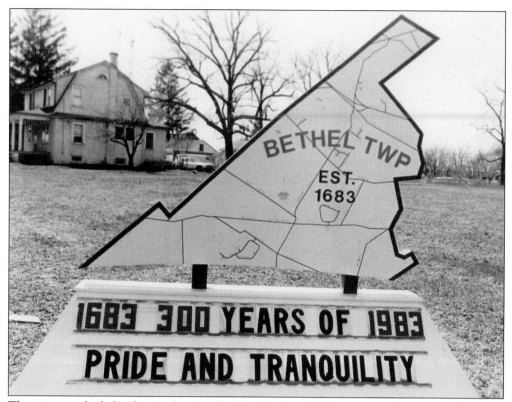

This sign may look familiar in that it pulled double duty. Well constructed, it was used again in 1983 to commemorate the township's founding. Today, it is still in used, as it is mounted in front of the township building. "BETHEL TWP—EST. 1683" was added, and the sign underneath was changed to say, "1683–1983 / 300 Years of Pride and Tranquility."

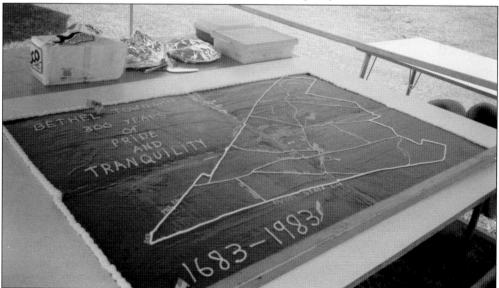

A large sheet cake was made based upon the unique shape of Bethel Township. This cake was made specifically for the corn boil, an annual social event currently put on by the township.

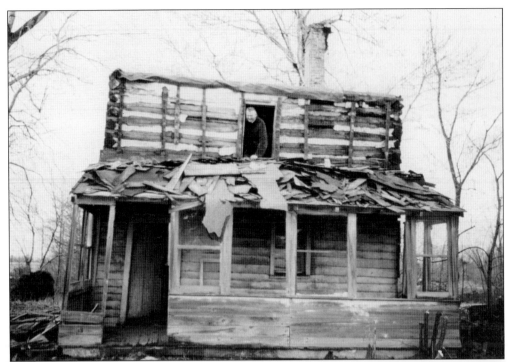

Another way that history has come alive is through the efforts of Dr. Mead Shaffer. This image shows the deplorable condition that the Southery Log House was in when Dr. Shaffer totally dismantled it in 1972 and moved it to be stored on his property a mile away from its original location. (Courtesy of Mead Shaffer.)

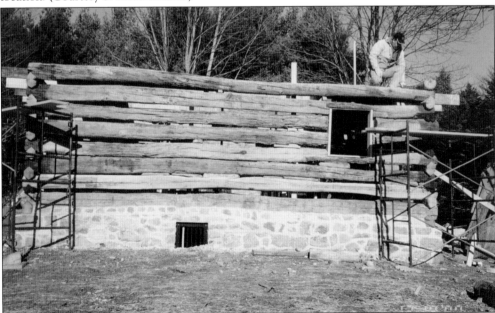

Dr. Shaffer was able to start the reconstruction project and complete it in 2002. A design that slants toward the rear and front permitted adjacent buildings to be built close to its sides. Thus, it is the basis for the Philadelphia row house. (Courtesy of Mead Shaffer.)

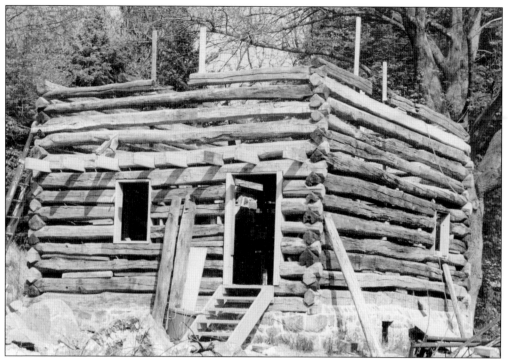

One of the main reasons why the house was able to be rebuilt was due to the use of chestnut logs, which are quite resistant to rot, in the original construction. Chestnut trees were wiped out by blight by the 1940s. (Courtesy of Mead Shaffer.)

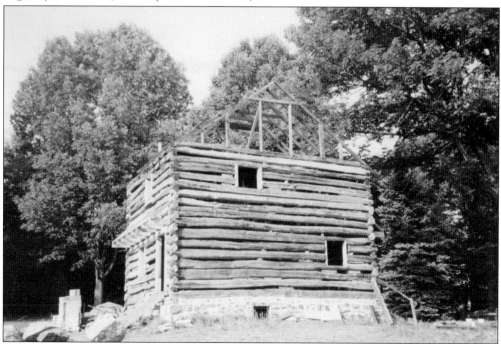

A few of the logs did need to be replaced, and pine was used for these replacement logs. Between the logs, plaster was used to seal the building. (Courtesy of Mead Shaffer.)

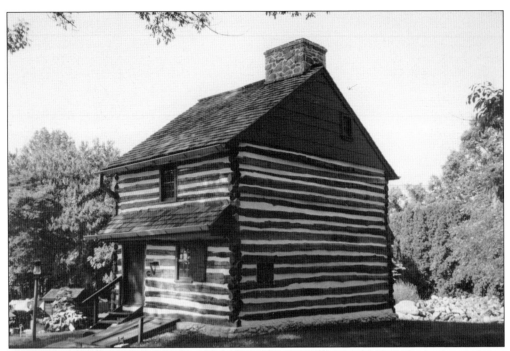

The reconstructed building is open to the public the Sunday after Mother's Day and the second Saturday in October for Founder's Day. It consists of two rooms on the first floor, and a fireplace is located between the rooms with its opening in the kitchen. Upstairs, two bedrooms are found as well as a loft on the third floor. The bedroom above the kitchen also has a fireplace. (Courtesy of Mead Shaffer.)

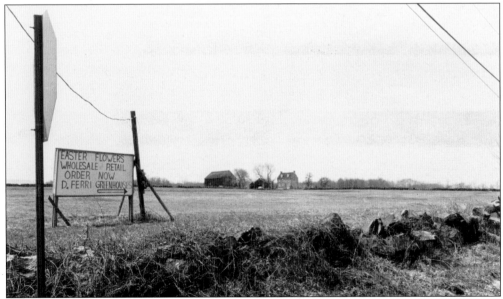

On this site was a log house, presumably the Pyle family home. An archeological dig was done in cooperation with the property owner, Thomas Booth. Prof. Heather Wholey of West Chester University, her students, and the Bethel Township Preservation Society participated in the dig. Artifacts that were found are housed in display cases at the Bethel Springs Elementary School.

To keep history alive, it is important to have reunions. Pictured here are former students of the Bethel Schools when they were one-room entities. By meeting and telling their stories to future generations, these citizens allow their experiences to live on. Pictured, from left to right, are (front row) Elizabeth Robinson, Dot Davis, and Lois Pennington; (back row) Wilbur Davis, Pete Robinson, Lucy Davis, Josephine and Tom McDaniel, and Wilfred Davis. (Courtesy of Josephine Schott McDaniel.)

In the late 1990s, the Bethel Township Preservation Society was formed and incorporated much from the Bethel Township Historical Society. Here, Reece Thomas, founding member of both organizations, explains to the young man who found it that the water bottle on view was from the historic Bethel Springs Water Company. (Courtesy of Jay Childress.)

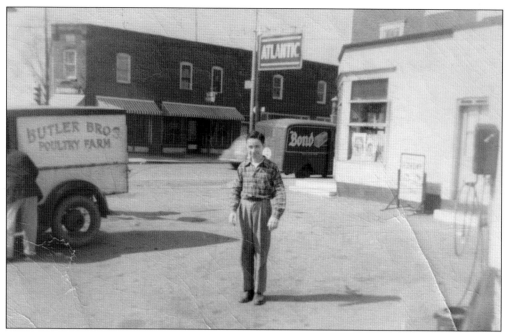

Many would say the reason to learn history is so that mistakes are not repeated, but sometimes it is simply just fun to recreate history. In these two pictures, one can see the late Reece Thomas. One image was taken when he was a child and shows him standing next to the Butler Poultry Truck at the intersection of Chichester and Meetinghouse Roads. Years later, Reece was able to purchase the truck and recreate the scene. The vehicle is still in the ownership of the Thomas family.

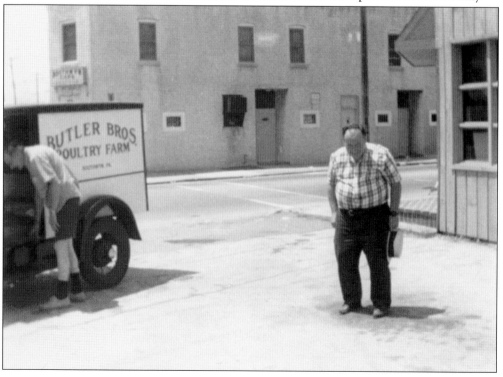

BIBLIOGRAPHY

Ashmead, Henry Graham. *History of Delaware County, Pennsylvania.* Philadelphia: L.H. Everts
 & Co., 1884.

Goodley, Rev. George Walter. *Bethel Township, Delaware County, Pennsylvania Thru Three Centuries.*
 Boothwyn, PA: Bethel Township Historical Society, 1987.

DISCOVER THOUSANDS OF LOCAL HISTORY BOOKS FEATURING MILLIONS OF VINTAGE IMAGES

Arcadia Publishing, the leading local history publisher in the United States, is committed to making history accessible and meaningful through publishing books that celebrate and preserve the heritage of America's people and places.

Find more books like this at
www.arcadiapublishing.com

Search for your hometown history, your old stomping grounds, and even your favorite sports team.